# TREASURES OF AMERICAN FOLK ART

From the Collection of the Museum of American Folk Art

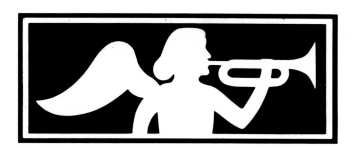

Introduction and Commentaries by
Robert Bishop, Director, the Museum of American Folk Art

Photographs by Seth Joel

Harry N. Abrams, Inc., Publishers, New York

On the Cover:

## SAINT TAMMANY WEATHER VANE

*Artist unknown. Found in East Branch, N.Y. Mid-nineteenth century. Copper, molded and painted, h. 9'.*

Some metal vanes were gilded; others, like this one, were painted in yellow ochre to simulate gold leaf. Saint Tammany is unique; no other American vane of such size and workmanship is known. Bullet holes indicate that even this treasure served as a target for prankish marksmen. He stood on a lodge building in East Branch, where his arrow pointed to the direction of the wind while he himself functioned as a symbol for an organization known as "The Improved Order of Redmen." Numerous fraternal societies adopted Indian customs and dress and pledged their moral and aesthetic allegiance to Tammany, chief of the Delaware Indians, a semimythical personage revered in Colonial America for his eloquence and courage. Such allegiance to patron-symbols was not uncommon in the early days of the republic, and some Colonial soldiers who fought against British Sons of St. George or Sons of St. Andrew dubbed themselves Sons of St. Tammany. The unofficial canonization has persisted.

Editor: Darlene Geis
Designer: Gilda Kuhlman

Library of Congress Catalog Card Number: 79-51125
International Standard Book Number: 0-8109-2218-5

© 1979 Harry N. Abrams, Inc.

Photographs of Saint Tammany, Smutt, Piety Quilt, Bird of Paradise Quilt, and Horse Weather Vane are from the Museum of American Folk Art. All others were taken especially for this book by Seth Joel.

Published in 1979 by Harry N. Abrams, Incorporated, New York
Printed and bound in Japan

# CONTENTS

# INTRODUCTION

Folk art is the art of the common man. Every American can understand and relate to it, for it represents a significant part of our cultural heritage. It was fashioned by artists without benefit of formal training who were often inspired to extoll the dignity of everyday life by making a purely utilitarian object a thing of beauty. The artist put his talent, sense of humor, and, most importantly, his heart into his creative efforts.

Establishing a concrete definition for the term *folk art* is especially difficult, for it is used to describe an incredible miscellany: portraits; genre paintings; schoolgirl watercolors; textiles including quilts, hooked rugs, needlework pictures, and samplers; ships' figureheads, cigar-store Indians, weather vanes, decoys, decorative stone and wooden carvings; pottery; useful household objects; painted and decorated country furniture—all produced between the seventeenth and late twentieth century.

Many of these pieces were handmade in the earlier centuries and grew out of European craft traditions transplanted to the American Colonial shores by settlers seeking a better life in the abundant New World. Paintings, textiles, one-of-a-kind weather vanes, and small decorative carvings are typical of this hand-craftsmanship.

Some later pieces are not the work of a single artist but reflect the combined efforts of several craftsmen laboring in a small shop or carving studio. Many wooden ships' figureheads, cigar-store Indians, three-dimensional shop signs, carousel figures, and circus wagons fall into this category.

Objects such as the commercial metal weather vanes that were mass-produced in vast quantities, are also sought out by collectors and museums alike. While "production weather vanes," strictly speaking, are difficult to classify as folk art, they are admired for their beautiful patina acquired through decades of exposure to the elements, as they turned in the wind.

During the late nineteenth and early twentieth century, successive waves of immigrants continued to bring European traditions to America. These traditions have served as a wellspring for the folk arts of today, in which a surprising number of naive artists, many of them working in personal and cultural isolation, are infusing folk expression with a new sense of vitality.

Folk art first gained recognition in the United States during the early twentieth century when American artists, returning home from Europe where their eyes had been opened to unfamiliar images, began to collect the flat, naive portraits, stylized landscapes, and three-dimensional objects fashioned during the earlier days of their homeland.

The first recorded exhibition of American folk art was presented at the Whitney Studio Club in New York City in 1924. Works of art were borrowed from the collections of such distinguished artists of the period as Charles Sheeler, Charles Demuth, and Yasuo Kuniyoshi.

The first museum in the United States to mount a major exhibition of American folk art was the Newark Museum, which in 1930 held a show entitled "American Primitive Painting." A year later in the 1931–32

season, the museum presented "American Folk Sculpture —The Work of Eighteenth and Nineteenth Century Craftsmen." Both shows were resounding successes, and critics admired the absence of pretense that distinguished the best pieces.

In 1932, the year of the second Newark exhibition, the Museum of Modern Art in New York City mounted an exhibition of major importance. "American Folk Art, the Art of the Common Man in America 1750–1900" featured 175 objects. Holger Cahill, the organizer of the show, wrote: "It is a varied art, influenced from diverse sources, often frankly derivative, often fresh and original, and at its best an honest and straightforward expression of the spirit of a people. This work gives a living quality to the story of American beginnings in the arts, and is a chapter intimate and quaint, in the social history of this country."

These exhibitions blazed the trail and the rest of the museum community soon followed with other shows. Every institution alert to new trends eagerly espoused the cause, and American folk art became as popular in the early 1930s as concern for ecology did in the early 1970s. This enthusiasm for America's vigorous folk expression has never waned.

Though many folk artists would be surprised at the attention lavished upon their work and astonished to find it reposing in museums, appreciation for it has continued to increase dramatically in the last few years. Today the folk arts are receiving their just recognition as one of the stronger currents in the mainstream of American artistic experience. Folk art is securely established in the art world and acknowledged by the museum and university communities. On the popular front, hardly a newspaper or magazine is published in which the field, in its many aspects, is not the subject of serious articles.

The Museum of American Folk Art, a nonprofit educational institution located in New York City, is the only metropolitan museum in the United States devoted exclusively to the preservation, presentation, and interpretation of American folk art. Since the granting of its charter in 1961 by the New York State Board of Regents, it has presented over seventy loan exhibitions ranging from gravestone rubbings to farm tools, from decorative accessories to the work of well-known folk painters and sculptors of the twentieth century, all focusing on the contributions made by America's folk artists.

The permanent collection of the Museum of American Folk Art is virtually a living encyclopedia of the wealth of Americana, as evidenced by the objects illustrated in this book. Symbolically these objects represent the wit, imagination, and latent creativity in each of us. They heighten appreciation for our forebears' ingenuity and grace in coping with the task of building America—a task more strenuous if less stressful than living in it today. Folk art challenges us, for it is a central force in much of our artistic expression. It continues to inspire us to create and recognize beauty in our everyday lives.

In recent years the permanent collection has grown dramatically. Important acquisitions such as the spectacular Bird of Paradise quilt top, fashioned near

Poughkeepsie, New York, between 1858 and 1863, have been purchased. Enthusiastic friends have made gifts to the Museum of outstanding pieces from their personal collections, so that an ever-increasing number of people can enjoy them: the Flag Gate from Herbert W. Hemphill, the perky, gaily painted rooster carved by Wilhelm Schimmel from Ralph Esmerian, the dazzling carousel horse, one of a pair from Laura Harding, and the *Circus Parade* painted especially for the Museum by the contemporary folk artist Kathy Jakobsen. Other major gifts have been pledged, among them the in-comparable collection of American figural whirligigs pledged by Dorothy and Leo Rabkin.

There is a joy inherent in folk art that is instantly recognizable, kindling an answering delight in the viewer. The spectators at our exhibitions smile a lot, and sometimes you can hear them chuckle out loud. *Treasures of American Folk Art,* with its giant-sized colorful illustrations, is another way of sharing these objects with the public at large.

Robert Bishop

# STANDING MAN WHIRLIGIG

*Artist unknown. Eastern United States. Second quarter of the twentieth century. Wood, painted, h. 28".*

Whirligigs, or wind toys, were probably first crafted in the eighteenth century by whittlers for their own amusement. One of the earliest references to these ingenious animated figures was made by Washington Irving in his story "The Legend of Sleepy Hollow," written in 1819. "Thus, while the busy dame bustled about the house, or plied her spinning-wheel at one end of the piazza, honest Balt did sit smoking his evening pipe at the other, watching the achievements of a little wooden warrior, who, armed with a sword in each hand, was most valiantly fighting the wind on the pinnacle of the barn." (Promised anonymous gift)

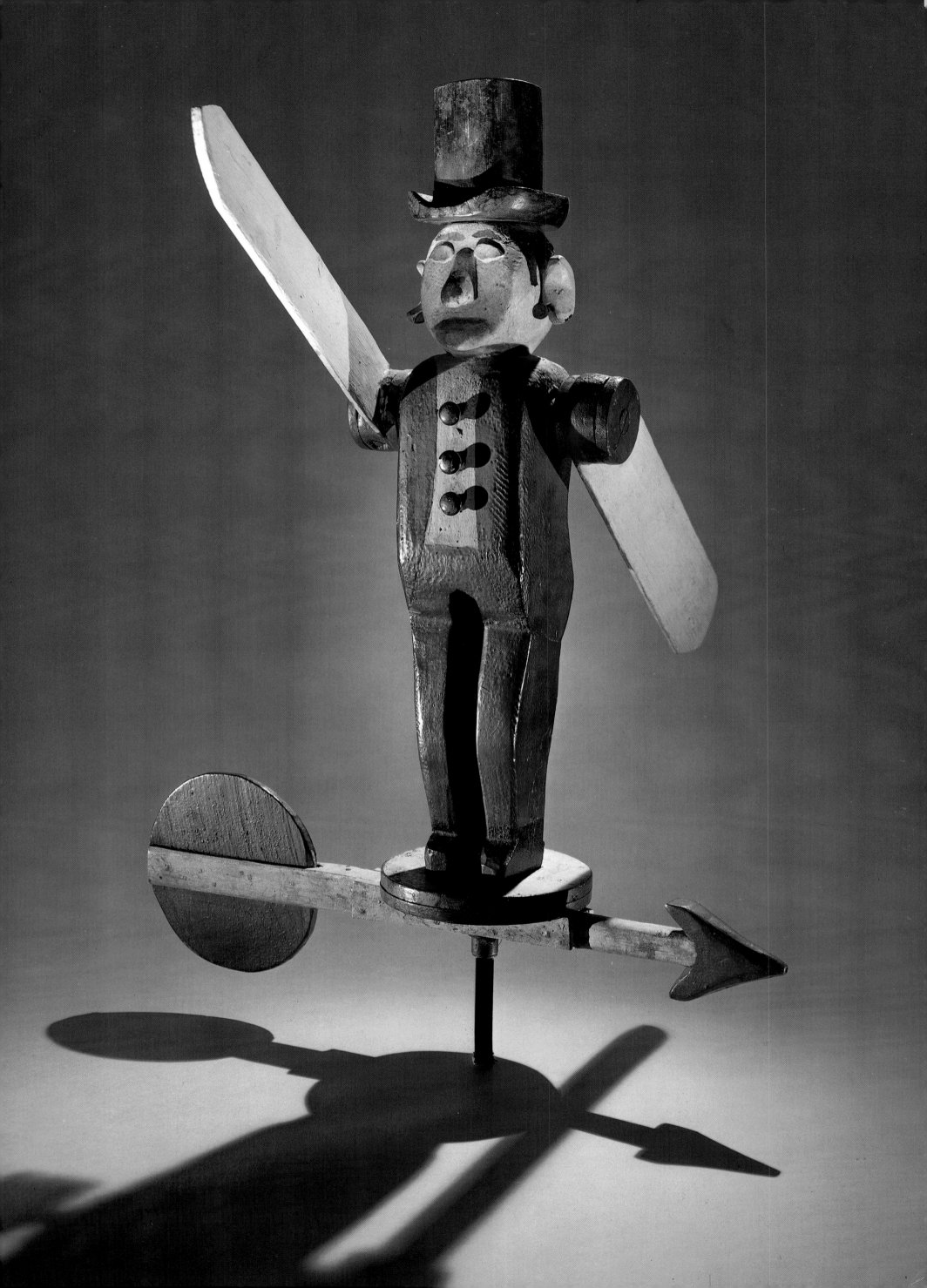

# CAROUSEL HORSE

*D. C. Muller & Bro. Shop. Philadelphia, Pa. 1902–9.*
*Wood, carved and painted, glass jewels and*
*horsehair, h. 62".*

The carving of the ears identifies this horse as the work of Daniel Muller. Both Daniel and his brother Albert were excellent carvers who learned their craft under the master carver Gustav Dentzel. When they left Dentzel to form their own firm, they specialized in making fine horse-drawn chariots for carousels. (Gift of Laura Harding)

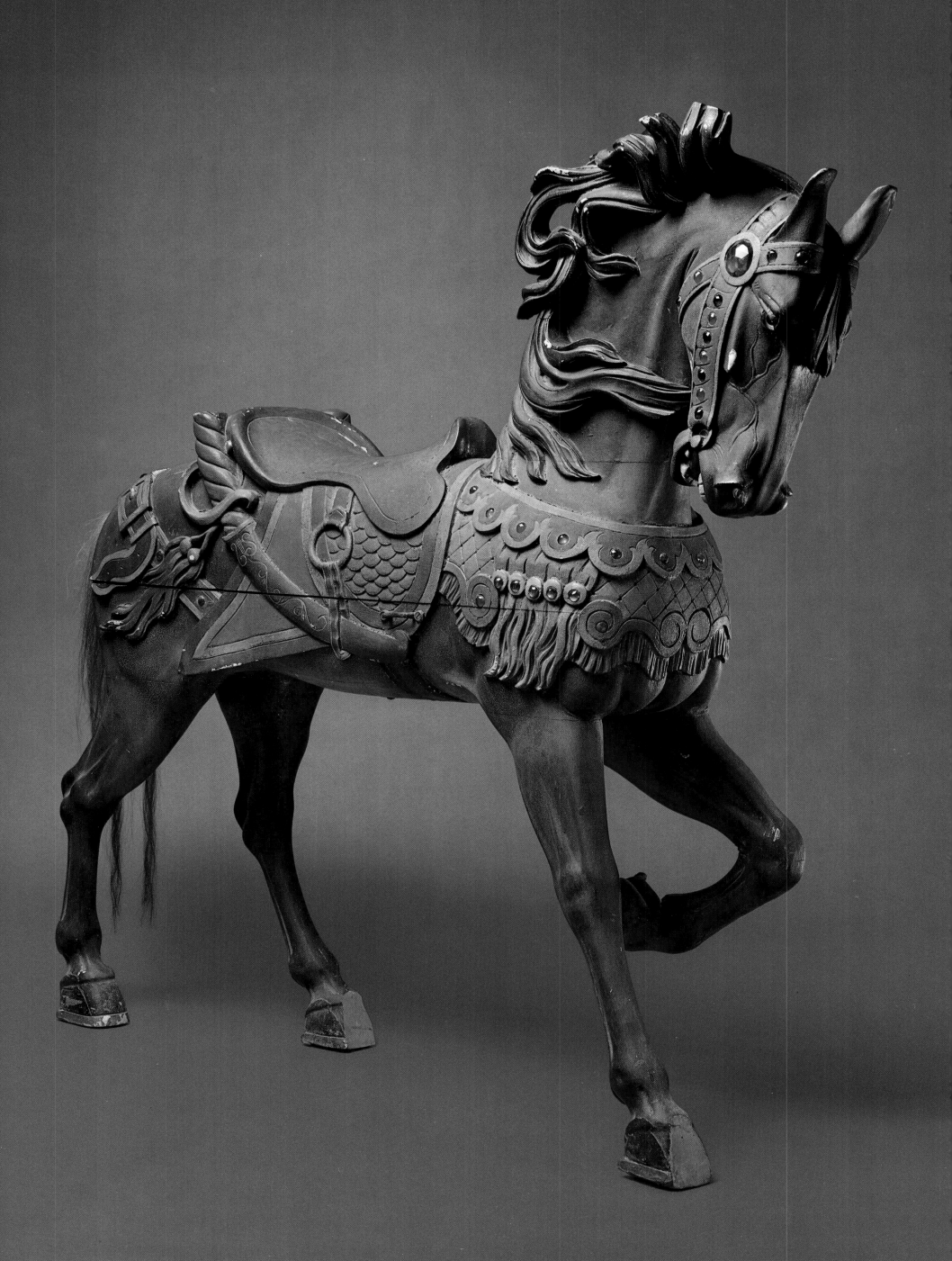

# CIRCUS PARADE

*Kathy Jakobsen. Michigan. 1979. Oil on canvas, 24 x 36".*

During the nineteenth century the circus parade was an important event in small towns as well as major cities across the country, routinely attracting record-breaking crowds. The artist chose to set this lively representation on a fantasy Fifty-ninth Street in New York City—note the Argosy Book Store and their next-door neighbor Harry N. Abrams, Inc.—with a turnout of enthusiastic metropolitan types lining the sidewalks. Kathy Jakobsen is one of America's foremost contemporary folk artists. A native of Michigan, her rural paintings reflect that state's Upper Peninsula while her naive city scenes draw upon her memories of older sections of Detroit. Her work is represented in the collections of leading cultural institutions throughout the United States. (Gift of the artist)

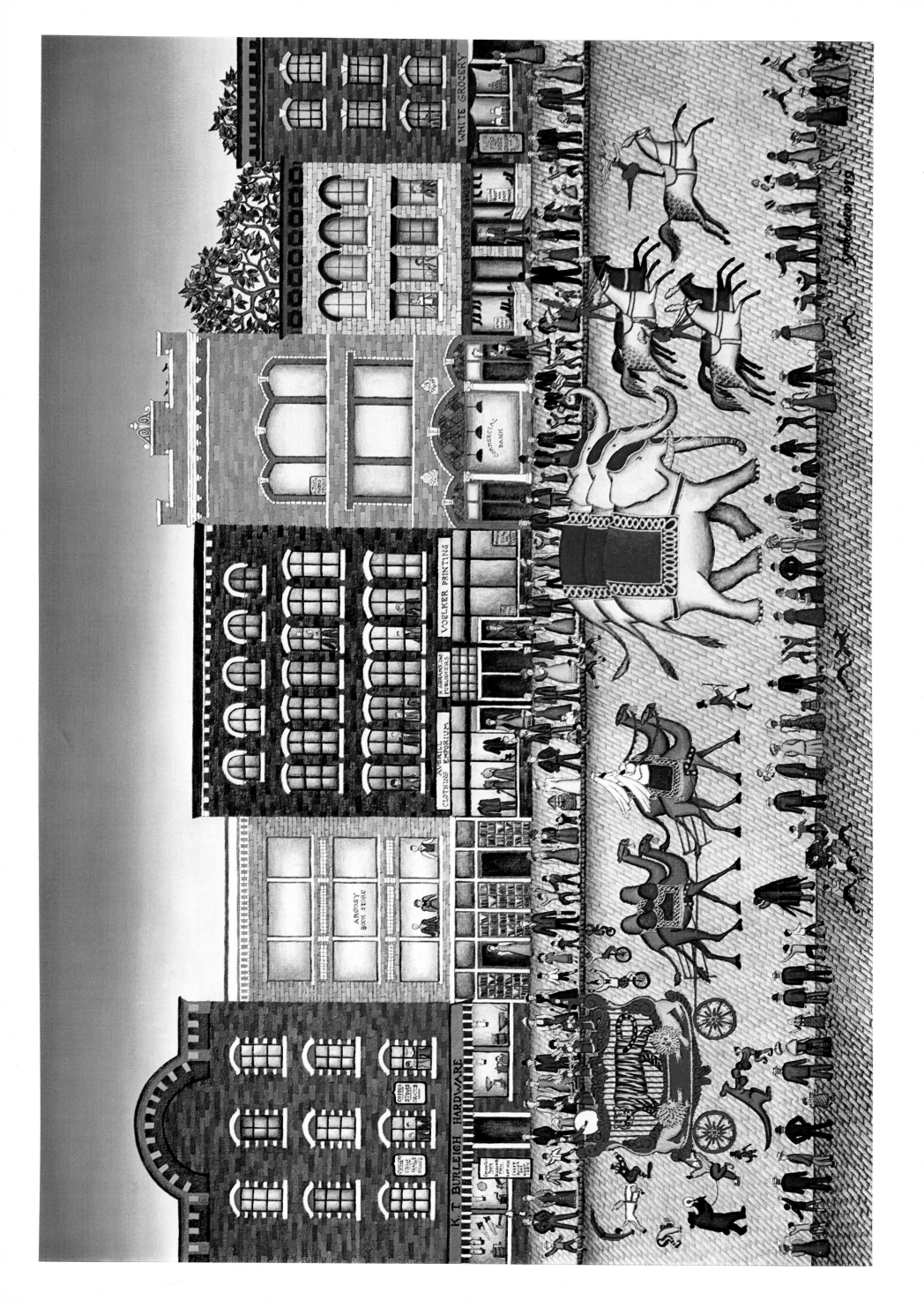

# WITCH WHIRLIGIG

*Artist unknown. New Hampshire or Massachusetts.*
*Mid-nineteenth century. Wood, painted, h. 11 1/2".*

Since the time of the infamous witch trials at Salem, Massachusetts, during the seventeenth century, the image of the witch has been imprinted upon the New England psyche. During the nineteenth century, witch scarecrows, weather vanes, and whirligigs were especially popular. This gaily painted and decorated whirligig is fitted with a broom that is topped by a propeller. (Promised gift of Dorothy and Leo Rabkin)

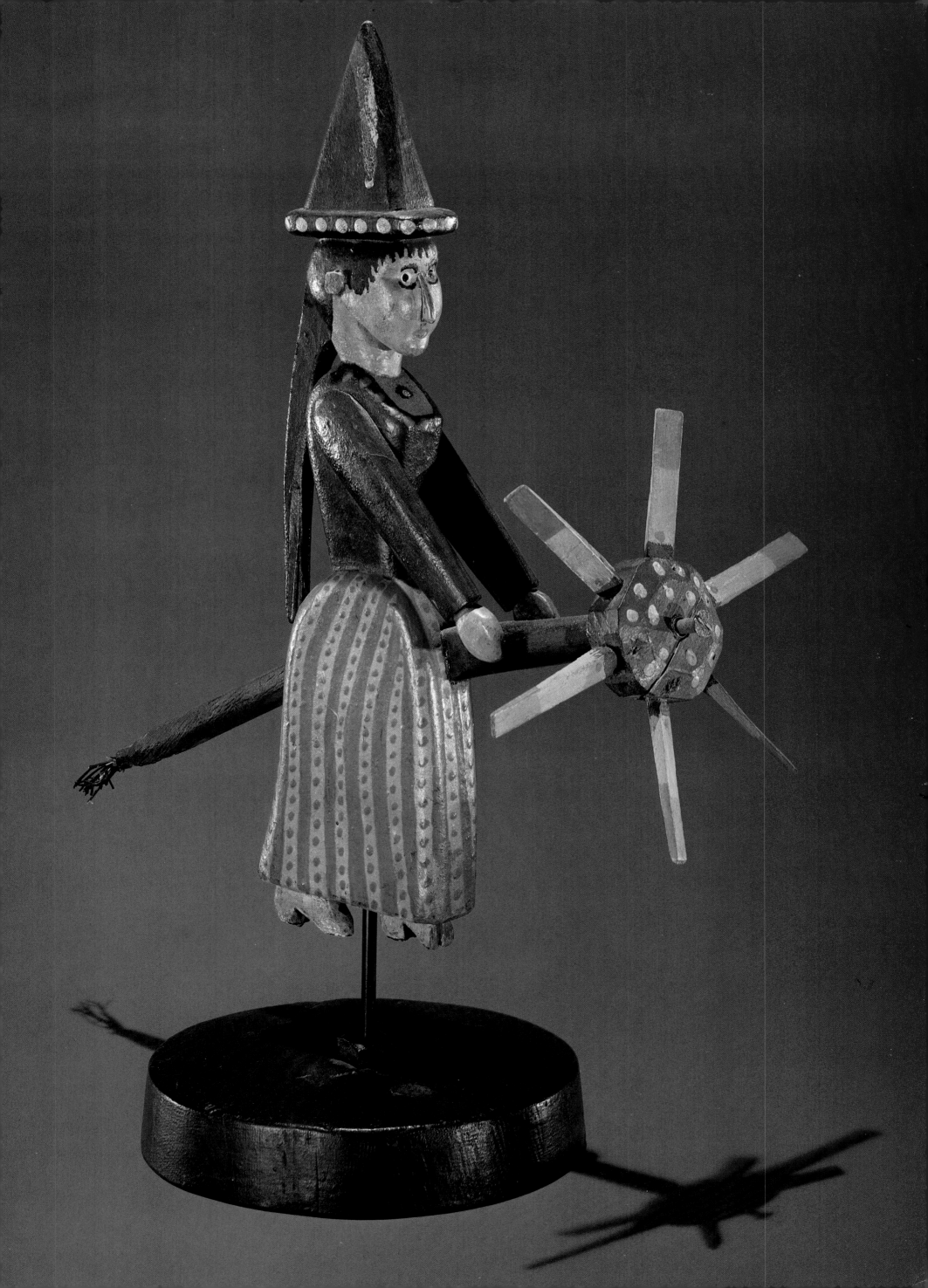

## TEMPERANCE CARVING

*Ned Cartledge. Atlanta, Ga. 1970. Wood, carved
and painted, 28 x 28".*

Cartledge's vehement denunciation of alcohol and drugs
includes a depiction of Satan welcoming intemperate
users to Hades. He has inscribed Satan's shirt with the words
"Welcome Boozers and Users." (Promised anonymous gift)

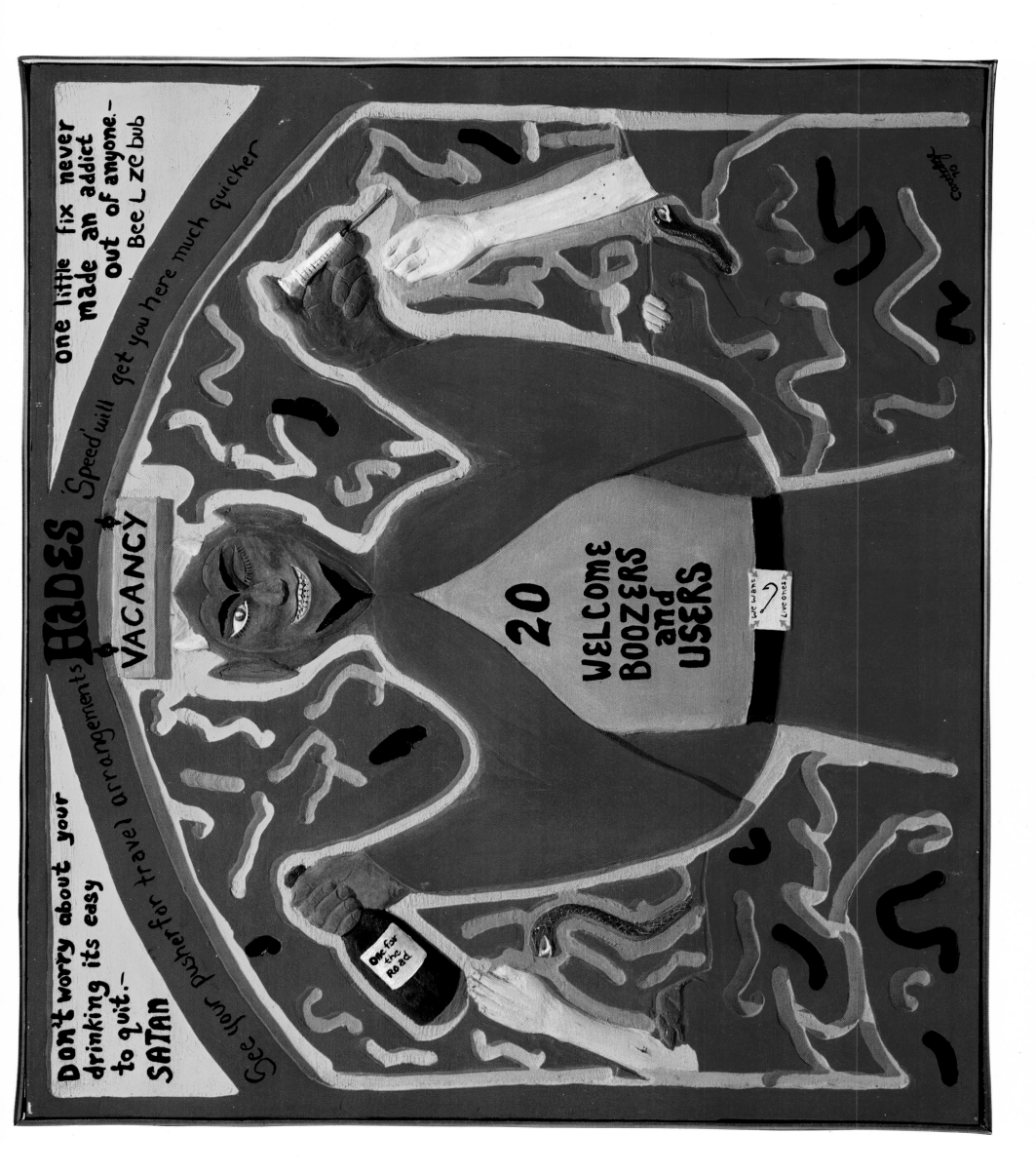

# FISH DECOYS

*Midwestern United States. Late nineteenth or early*
*twentieth century. Wood, leather, tin and other metals,*
*l. of longest decoy, 34".*

Fish decoys, modeled after such fish as catfish and sturgeon, were used almost exclusively in the Great Lakes area up until the middle of this century. The winter fisherman built a small windowless shanty over a hole cut in the ice. The shanty's interior was usually painted black so that a curious fish, investigating the decoy that had been dropped through the hole, could be seen through the translucent water by the fisherman waiting in the dim light to spear him.

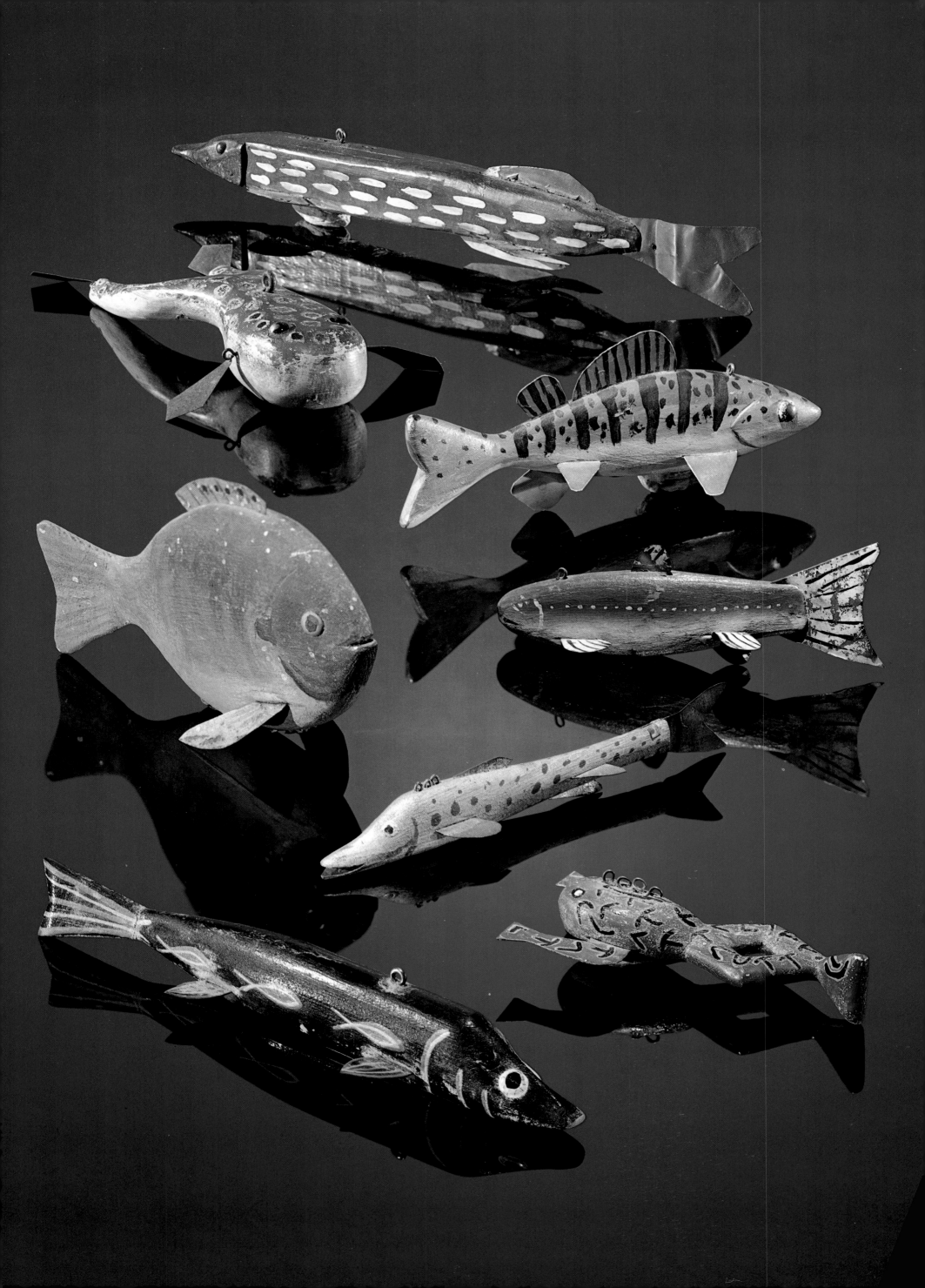

# SMUTT, THE ORANGE CAT

*Artist unknown. Found in Fryeburg, Me. Mid-nineteenth century. Oil on canvas, 21 1/2 x 18".*

Animal portraits were especially in demand during the last half of the nineteenth century. Smutt obviously was a pampered favorite in his day and his owner probably commissioned his portrait from an itinerant painter. Through this recorded likeness, one of the most popular paintings ever exhibited at the Museum, Smutt enjoys an ever-increasing number of admirers. (Shown at the Museum of American Folk Art in the special exhibition "American Cat-alogue, The Cat in American Folk Art"; Private collection)

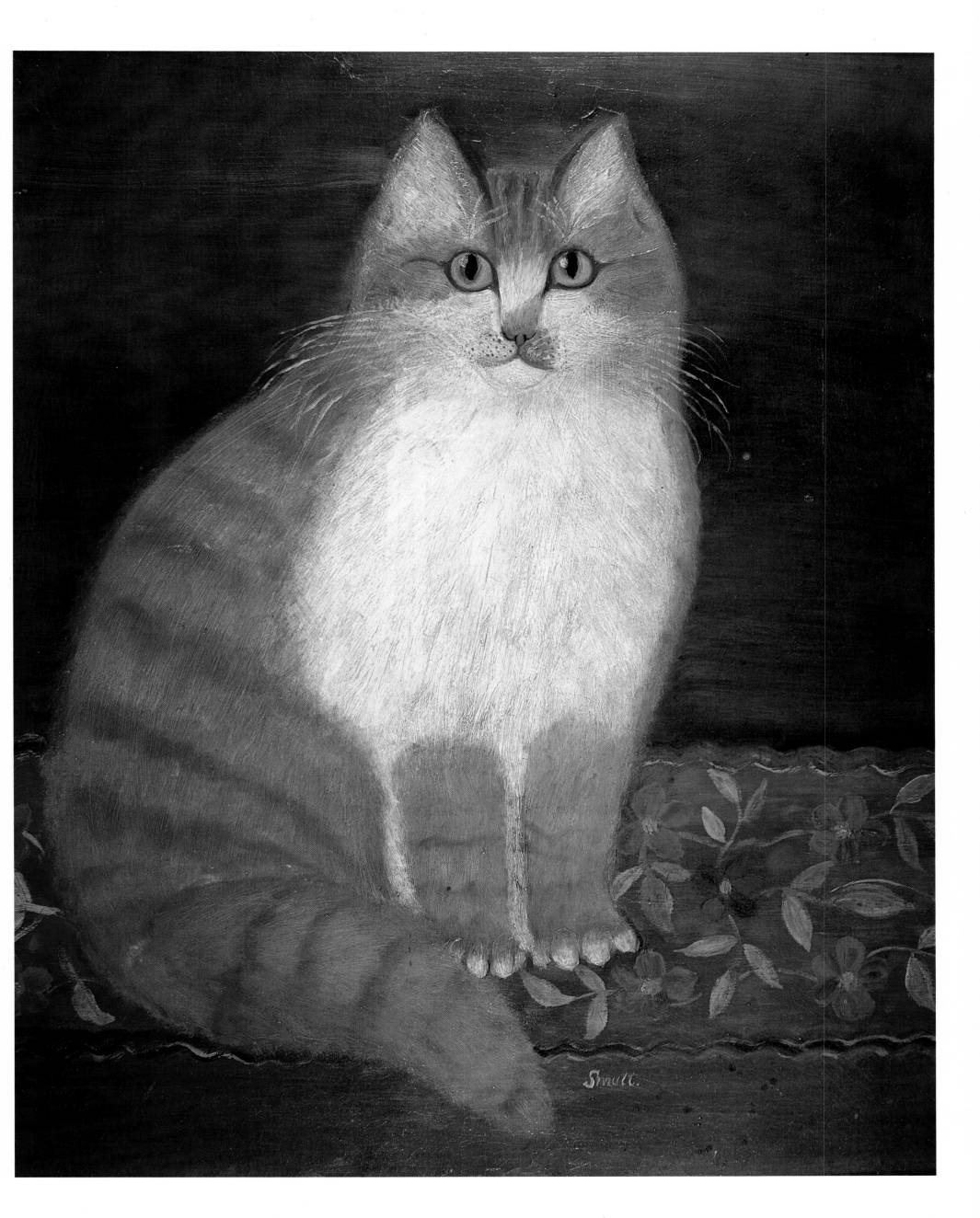

# GABRIEL WEATHER VANE

*Artist unknown. New England. c. 1840. Sheet iron,
polychromed, h. 29 1/4".*

Metal weather vanes are either flat silhouette or three-dimensional pieces and were usually painted for protection from the weather. Though this weather vane is complex in pattern, it was designed so that its silhouette would stand out boldly against the sky, its soundless trumpet pointing out the direction of the wind. Angels like Gabriel were favorite subjects for church weather vanes. (Gift of Mrs. Adele Earnest)

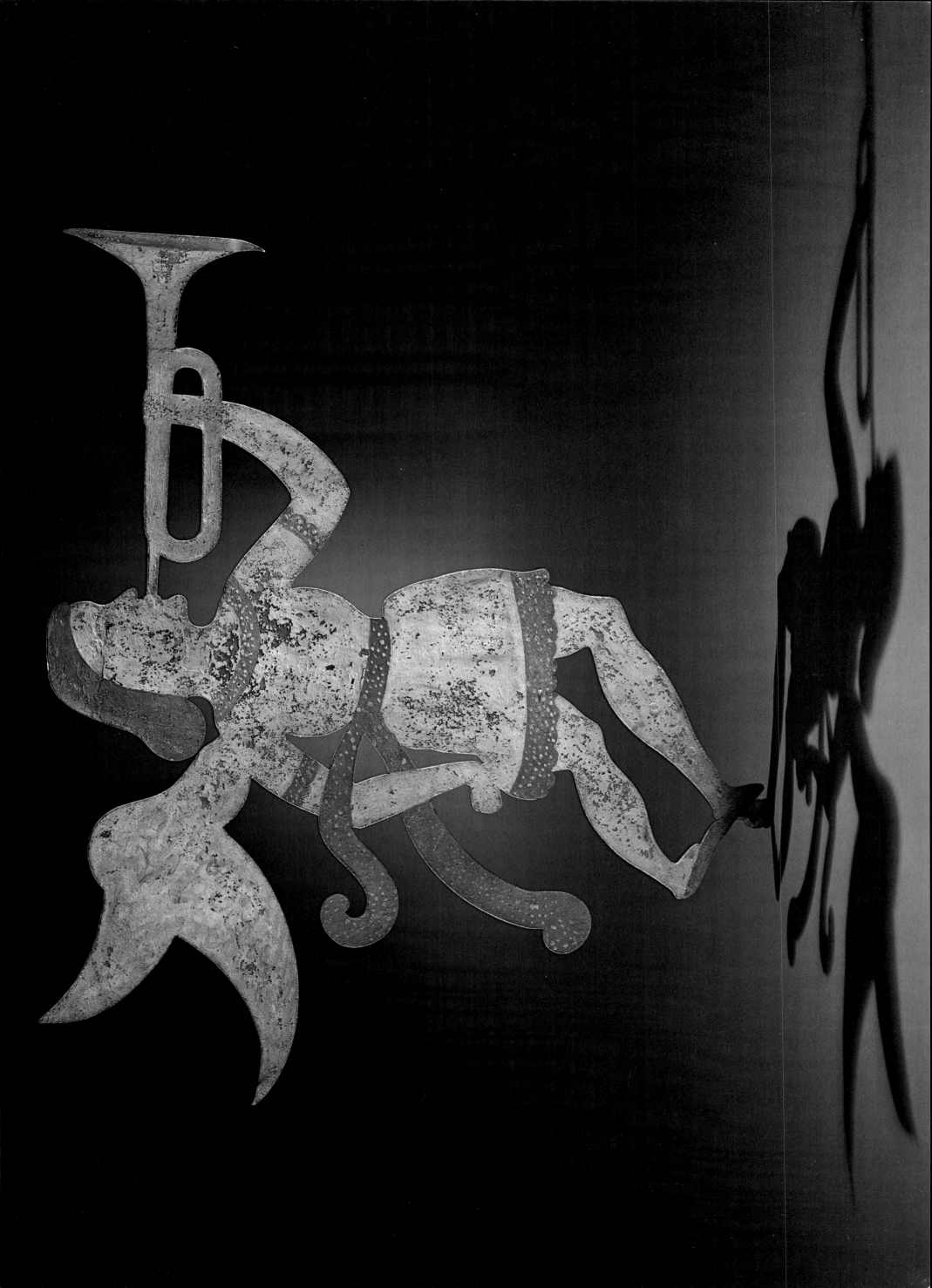

# PIETY QUILT

*Signed and dated "Maria Cadman Hubbard, 1848."*
*Probably New England. 88 ½ x 81 ½".*

The pious sayings are constructed of tiny squares and rectangles of material pieced together to form the letters. Several pieced quilts which incorporate Biblical quotations were created in America during the nineteenth century, but they are very rare. This quilt is unusual in that the needlewoman responsible for it chose to use only two colors in its execution.

Little acts of kindness
Little words of love

Make our earthly eden
like our Heaven above

Is our Home a Heaven

Heaven is our Home

Peace be still

Kind Words Never Die

Forgive as you hope to be forgiven

Earth has no sorrow Heaven cannot heal

Be still and know that I am God

No Cross No Crown

Walk with me

Oh sacred Patience with my soul abide

There is a magic in kindness that springs from above

Maria Cadman Hubbard aged 79

If you can not be a Golden Pipp and don't turn crabapple

Abide with us

Love one another

1848

# BULTO

*Attributed to José Ortega. New Mexico. 1870–1900.*
*Wood and gesso, polychromed, h. 45 1/2".*

The folk-art style of New Mexico is distinctive, having been influenced by the religious imagery of the Spanish missionaries who came to the area in the sixteenth and seventeenth century. The *bulto* is a sculpture which usually depicts a saint. Ortega's style of *bulto* has been described as "flat figure." In spite of his indifference to realism and his deliberate stylization of form and detail, many of Ortega's *bultos* resemble living New Mexicans of Spanish descent. This suggests that he may have used relatives or neighbors for models. (Anonymous gift)

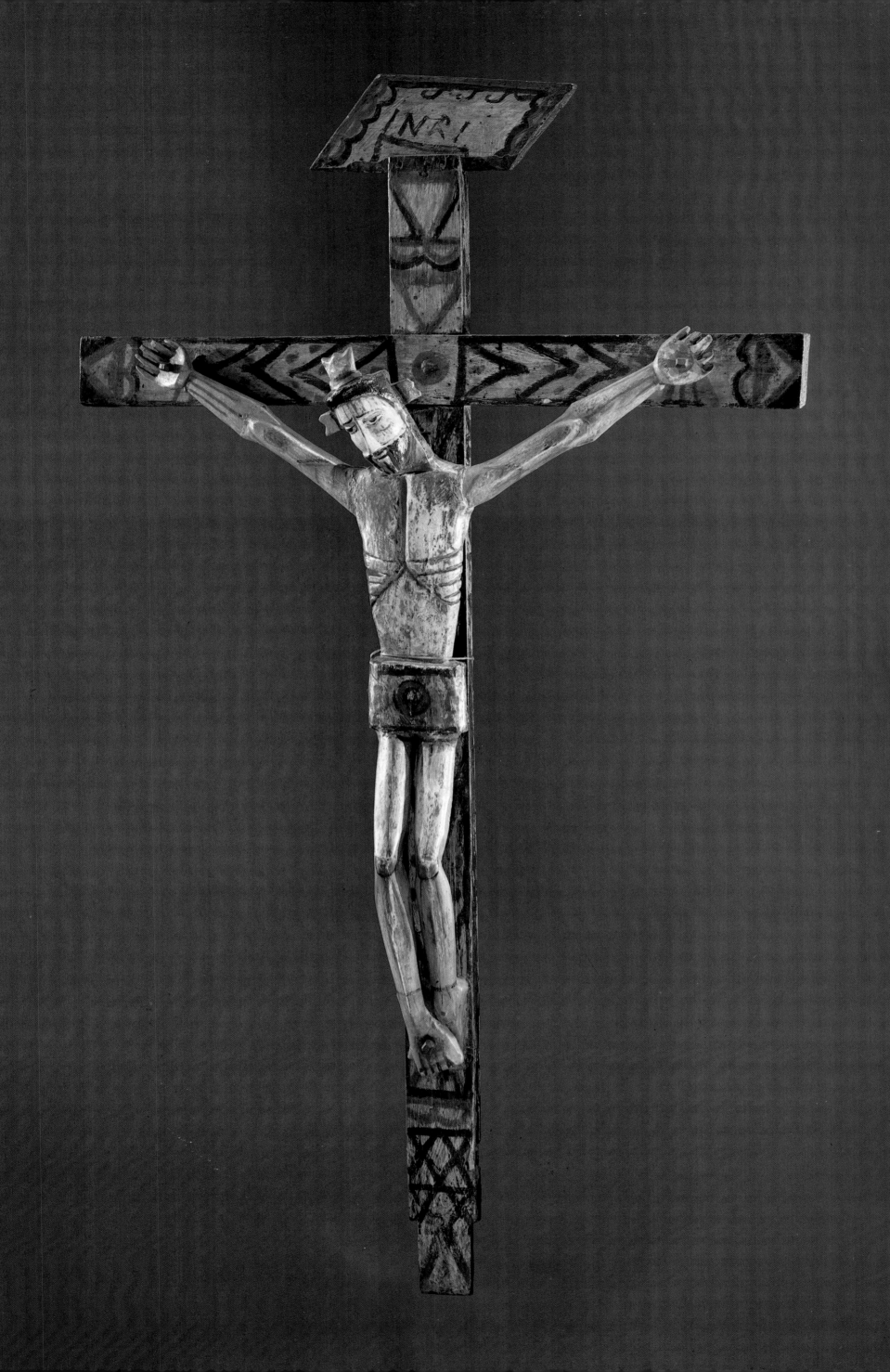

# THE BIG FARM IN THE SPRING

*Mattie Lou O'Kelley. Georgia. 1976. Oil on canvas,*
*36 x 24".*

Mattie Lou O'Kelley, a contemporary naive painter, records her childhood experiences in rural Georgia. Many modern-day folk artists execute "memory" pictures illustrating life-styles that are fast disappearing. (Gift of the artist)

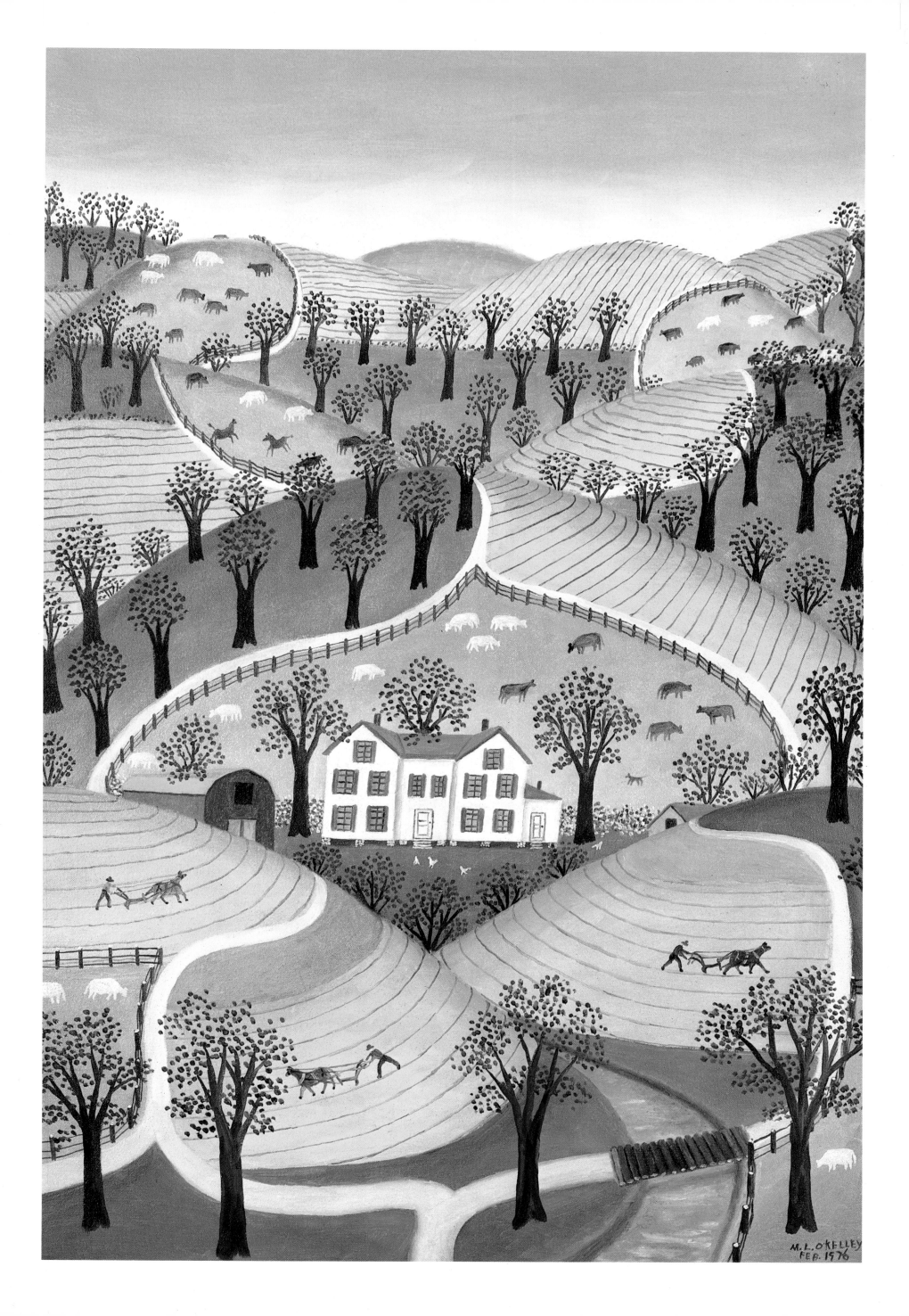

# COW WEATHER VANE

*Attributed to L. W. Cushing and Sons, Waltham, Mass.*
*c. 1875. Cast and stamped copper, painted, l. of cow, 18".*

A hand-carved wooden form would have been used to make the mold from which this piece was created. Though weather vanes of this type were made in multiples, they are collected by folk-art enthusiasts, for each one has aged differently and many have developed a beautiful patina. Shooting at weather vanes was always a popular American prank, and this placid cow bears the pitted scars of beebees and bullets. (Gift of Mrs. Jacob M. Kaplan)

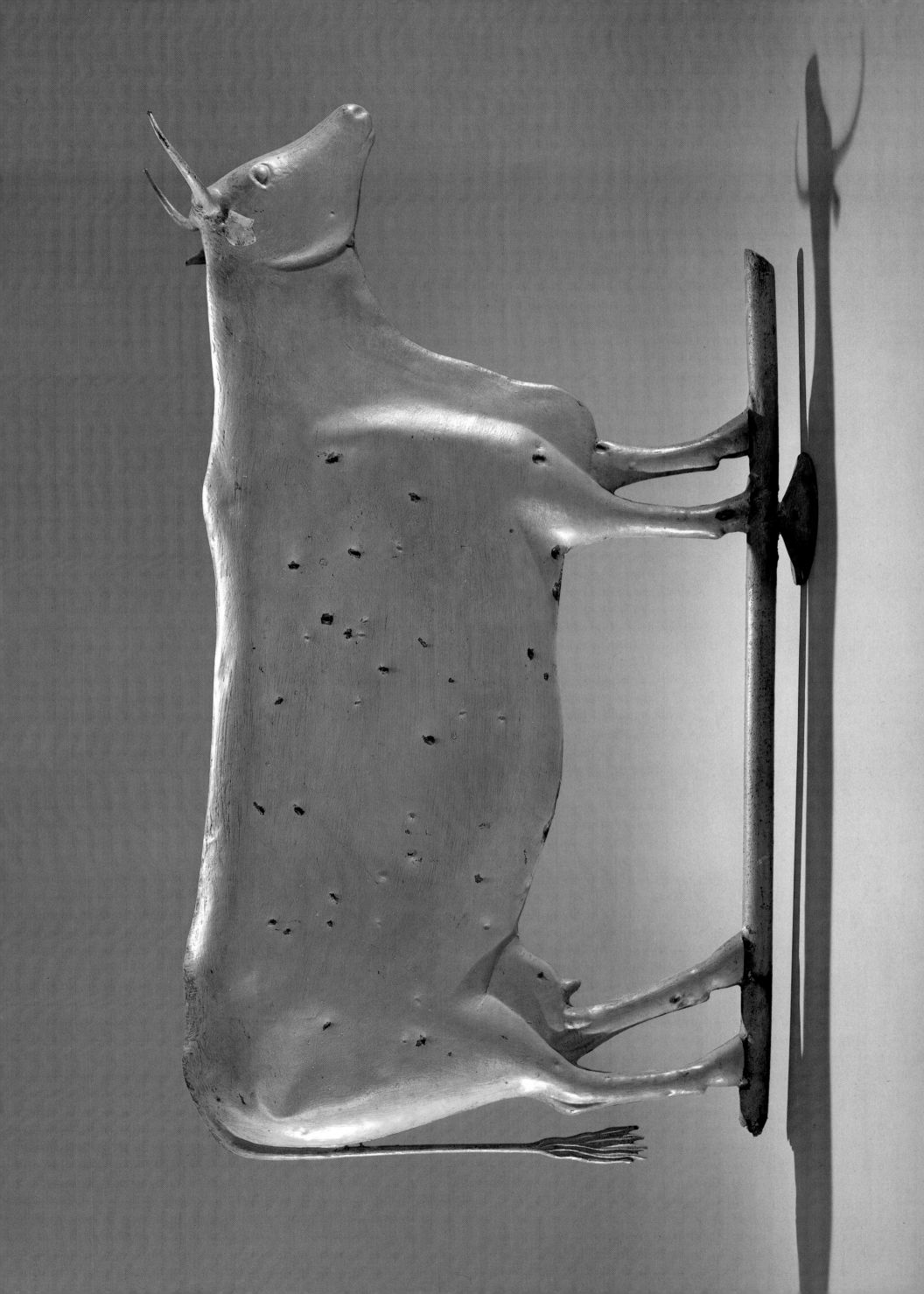

# SAMPLER

*Hannah Staples. Possibly Connecticut. c. 1786.*
*Silk on linen, 10 ³/₄ x 10 ¹/₂ ".*

The sampler, which Samuel Johnson defined in *A Dictionary of the English Language* as, "a pattern of work; a piece worked by young girls for improvement," was used before needlework handbooks became available. Young women practised stitches and stitch combinations on a piece of cloth, learning decorative motifs, letter styles, numerals, and various embroideries that they might later use on their household linens or personal items such as petticoats, nightgowns, and handkerchiefs. Some samplers were worked by little girls as young as eight years of age, serving an educational purpose by aiding them in the learning of the alphabet and numbers. (Gift of Louise and Mike Nevelson)

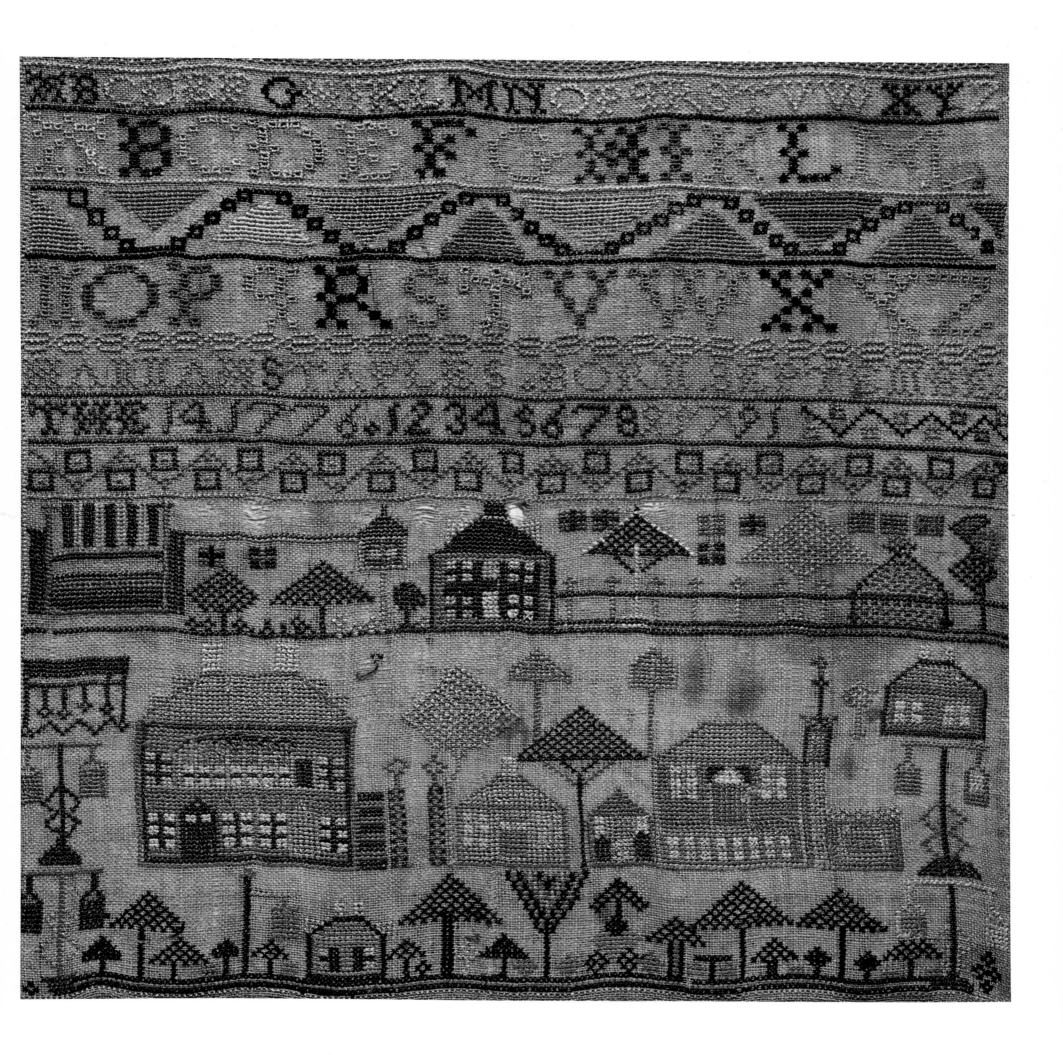

## AMISH COUPLE DOORSTOPS

*Artist unknown. Pennsylvania. c. 1870.*
*Cast iron, polychromed, h. 8 ¹/₂".*

These doorstops were made in Lancaster County and were given to an Amish housewife as a wedding present by her husband in the late 1800s. (Promised anonymous gift)

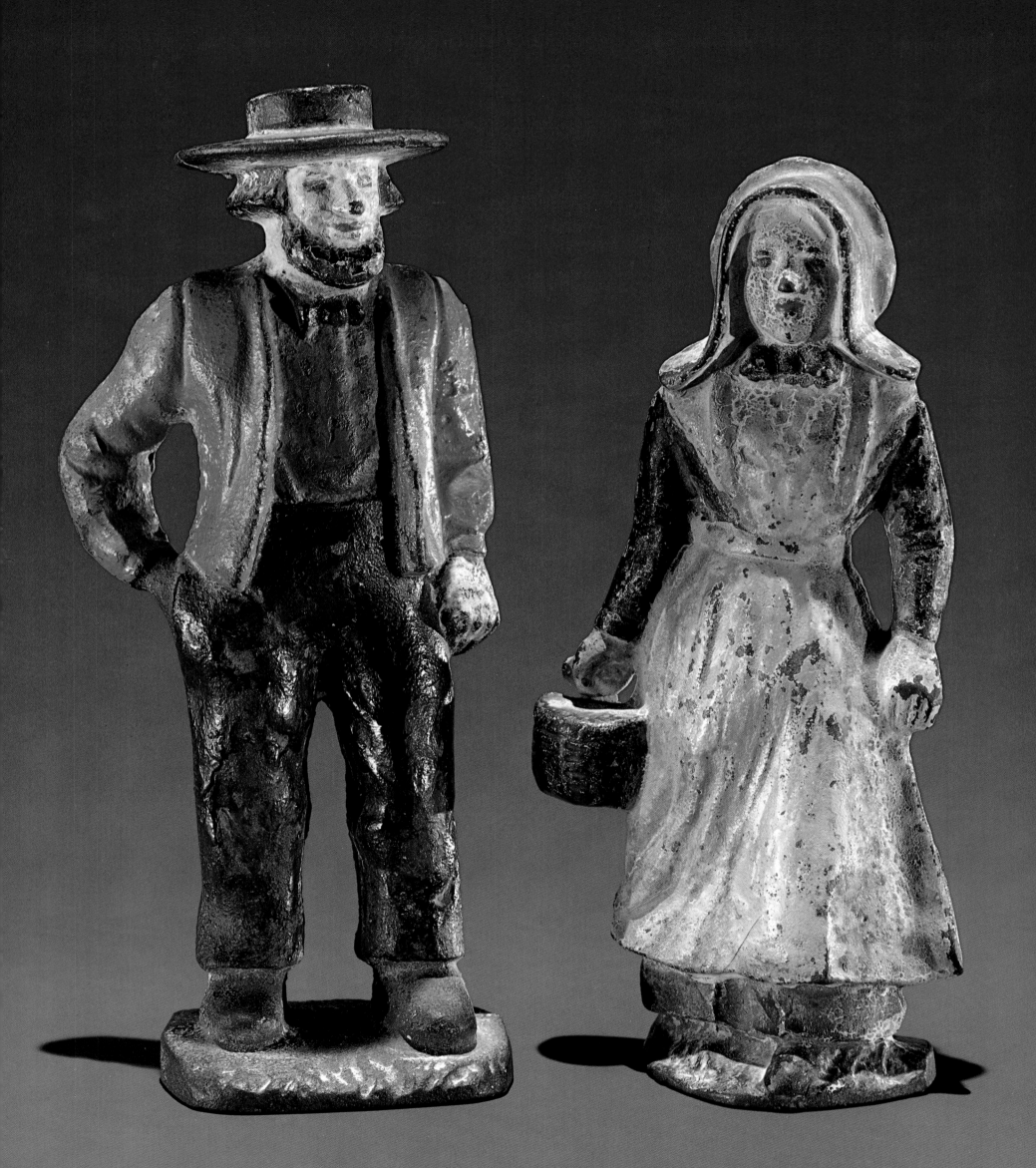

# SPIKE, THE BULLDOG

*A. Kline. New England. Late nineteenth century.*
*Oil on canvas, 28 x 22".*

Nothing is known of the artist who executed this delightful portrait of one of America's great natural comedians. Humor is an important ingredient of much folk art and Spike never fails to evoke a chuckle. (Exhibited at the Museum of American Folk Art in the special exhibition "The All-American Dog, Man's Best Friend in Folk Art"; courtesy R. Scudder Smith, *The Newtown Bee*)

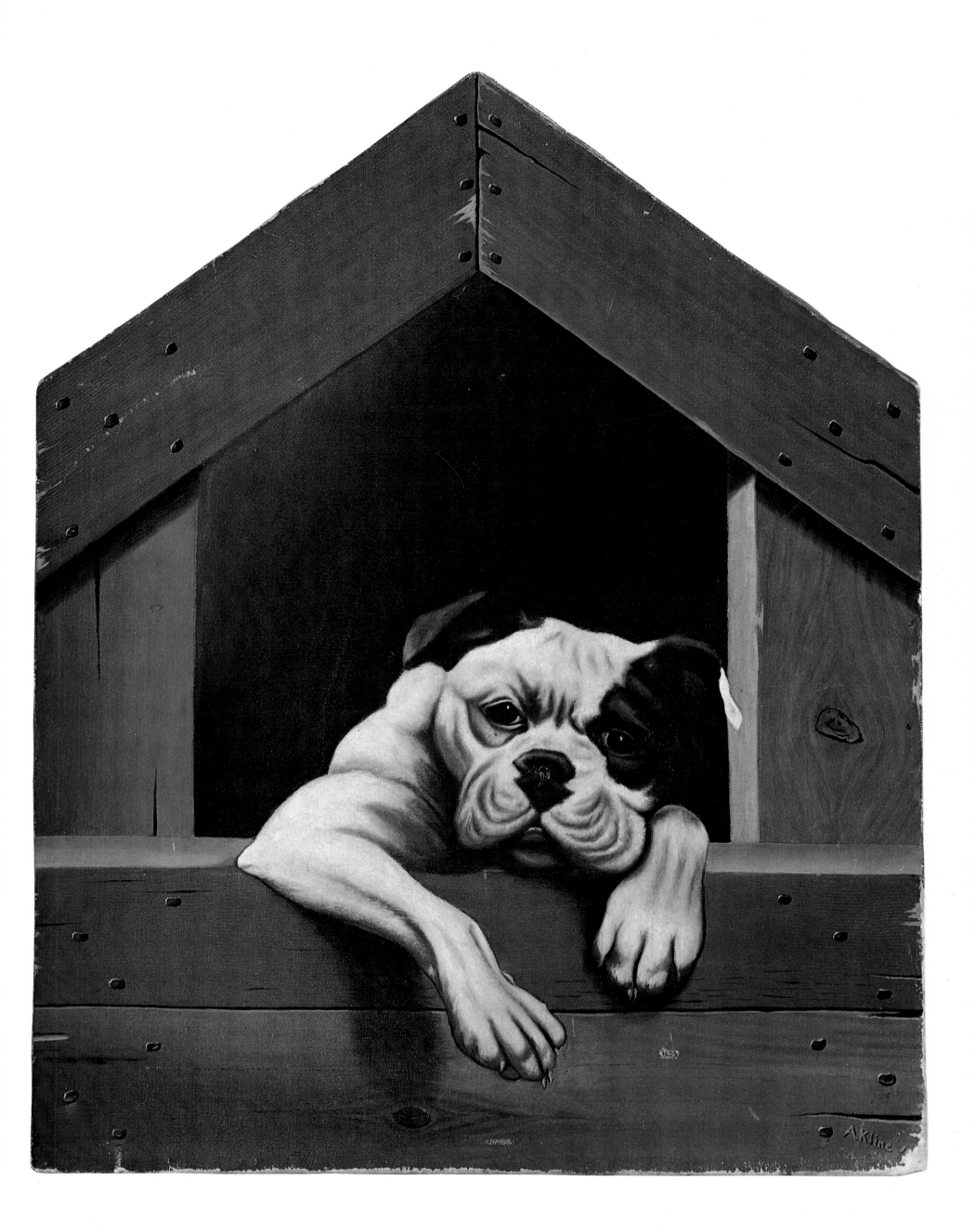

# BIRD DECOYS

*Sickle-billed curlew. Made at the Mason Factory,*
*Detroit, Mich. c. 1925. Wood, painted, l. 17".*
*Black duck. Charles E. "Shang" Wheeler. Stratford, Conn.*
*c. 1935. Wood, painted, l. 18".*
*Dowitcher. A. Elmer Crowell. Harwich, Mass. c. 1920.*
*Wood, painted, l. 12 1/4".*

Archaeologists have discovered that decoys were probably first used in America by Indians in the Southwest, who over a thousand years ago combined tightly bound reeds with feathers to create remarkable likenesses of canvasback ducks. The American colonists soon recognized the value of decoys in luring wildfowl within gunshot range and began to use them also. In the early nineteenth century, decoys were in great enough demand to enable wood-carvers to earn a good living by handcrafting them. During the last half of the nineteenth century, when improved firearms and a seemingly inexhaustible supply of wild birds gave rise to the national sport of duck hunting, it became feasible to manufacture, in specialized factories like the Mason firm, wooden birds that were skillfully carved and beautifully painted. These decoys served the professional hunter and the weekend sportsman well. Today many decoy carvers continue the art of handcraftsmanship; however, they usually focus upon ornamental birds, not working decoys. (Gifts of Alistair B. Martin)

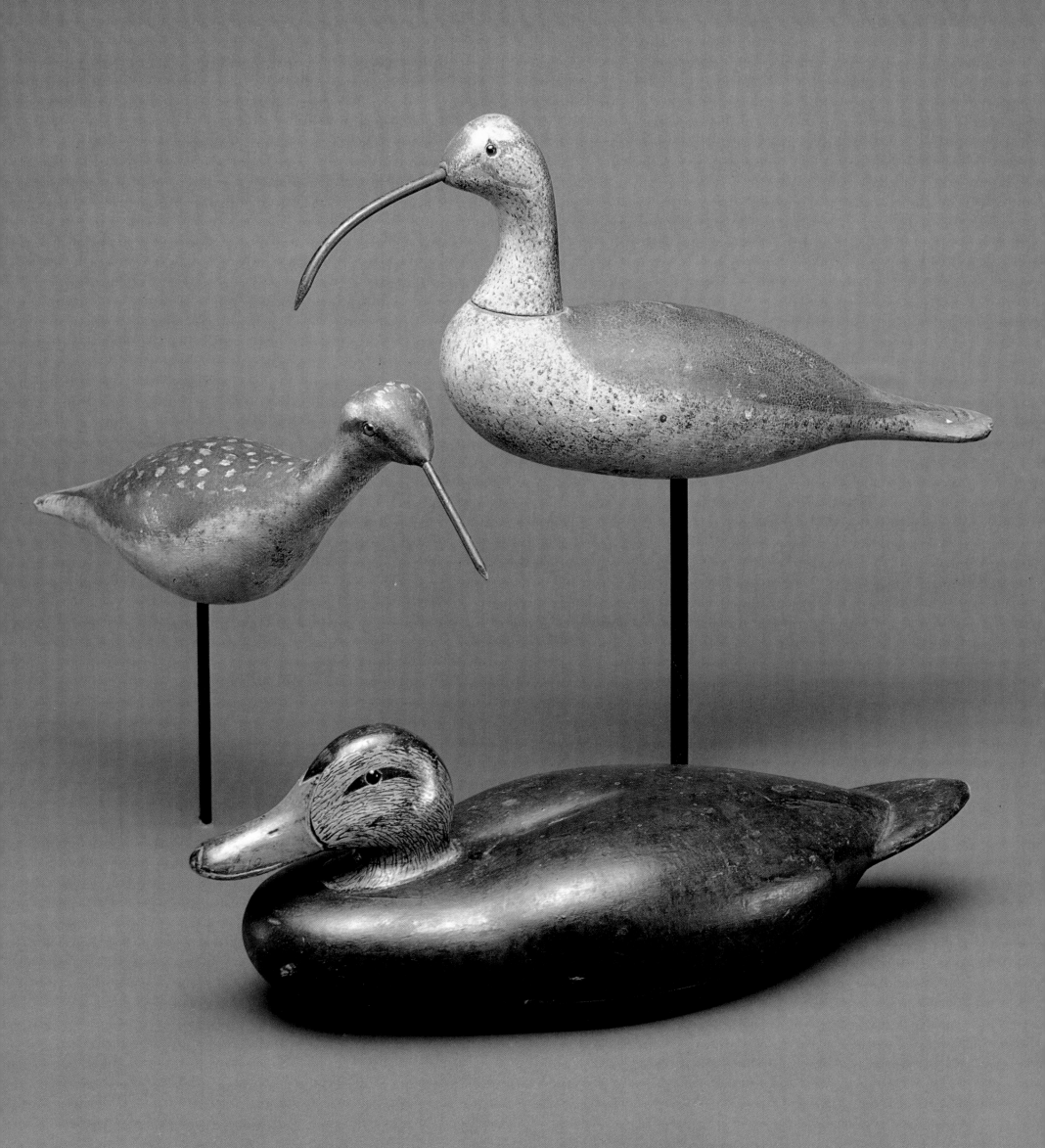

# APPLIQUÉ QUILT TOP IN THE BIRD OF PARADISE PATTERN

*Artist unknown. Poughkeepsie, N.Y. 1858–63. Cotton, silk, wool, and velvet on cotton, 87 x 71 ¹/₂ ".*

Because of its skillful design and vivid color, this quilt top is considered one of the great masterpieces of American needlework art. The appliquéd animals, birds, flowers, and people are evidence of the artist's remarkable talent at cutting her materials into fanciful forms. The cover was never quilted or backed. (Gift of Catherine G. Cahill, Mrs. Frederick M. Danziger, Ralph Esmerian, Barbara Johnson, Esq., Mrs. Jacob M. Kaplan, Mrs. Ronald Lauder, and William E. Wiltshire III)

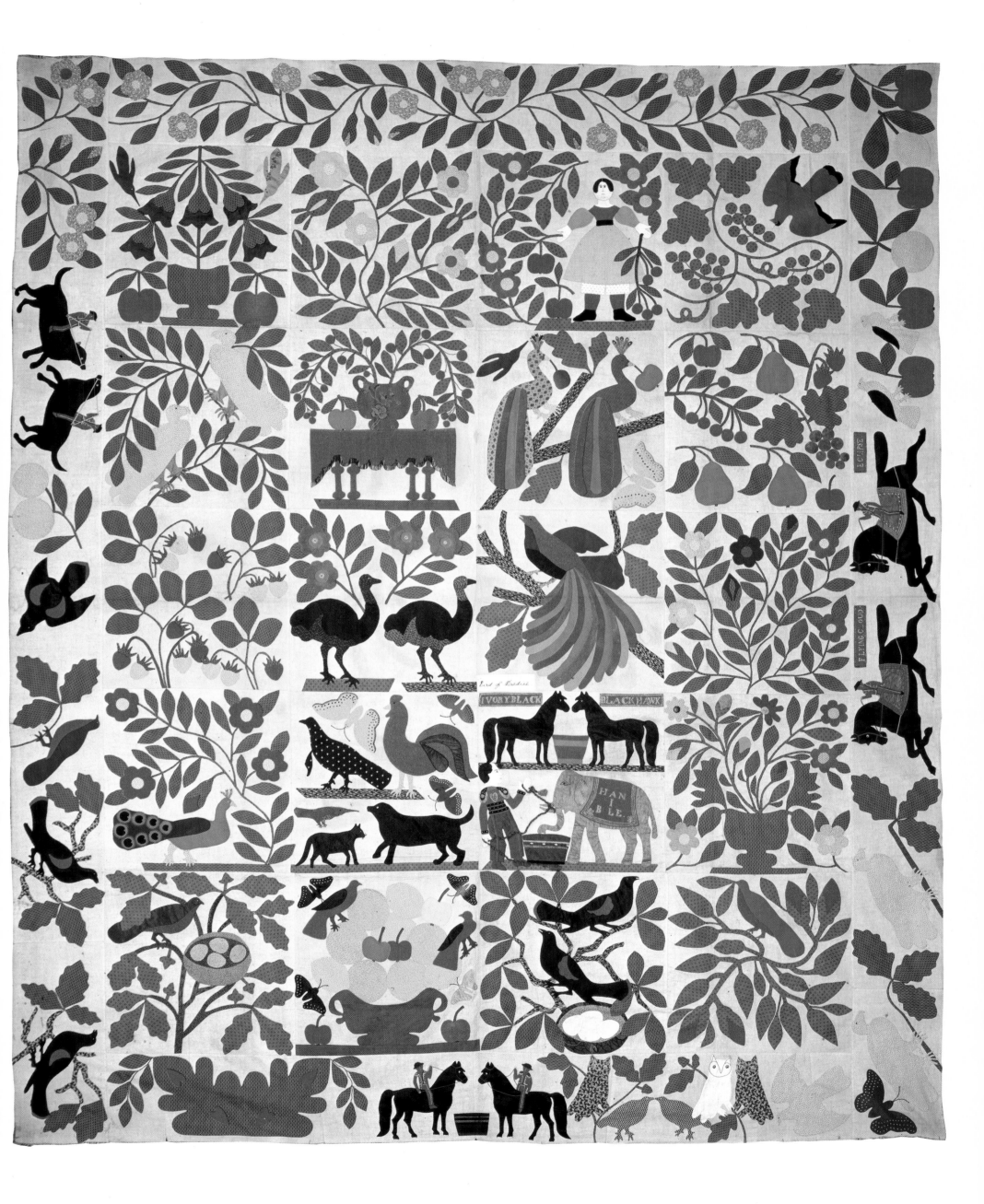

# HORSE WEATHER VANE

*Artist unknown. New England. c. 1875. Metal, painted,*
*l. 36 ½".*

During the nineteenth century, swift horses were especially valued, providing as they did the most economical means of travel. When harness racing became a national sport during the 1850s, highly touted racehorses served as the source of inspiration for weather vane designs. This spirited running horse is unusual, for it is not based upon a famous racehorse. The three-dimensional figure is much more finished than the earlier flat images cut from sheet metal. The dramatic treatment of the flaring mane and tail makes the vane a powerful folk-art statement. (Collection of Howard and Catherine Feldman)

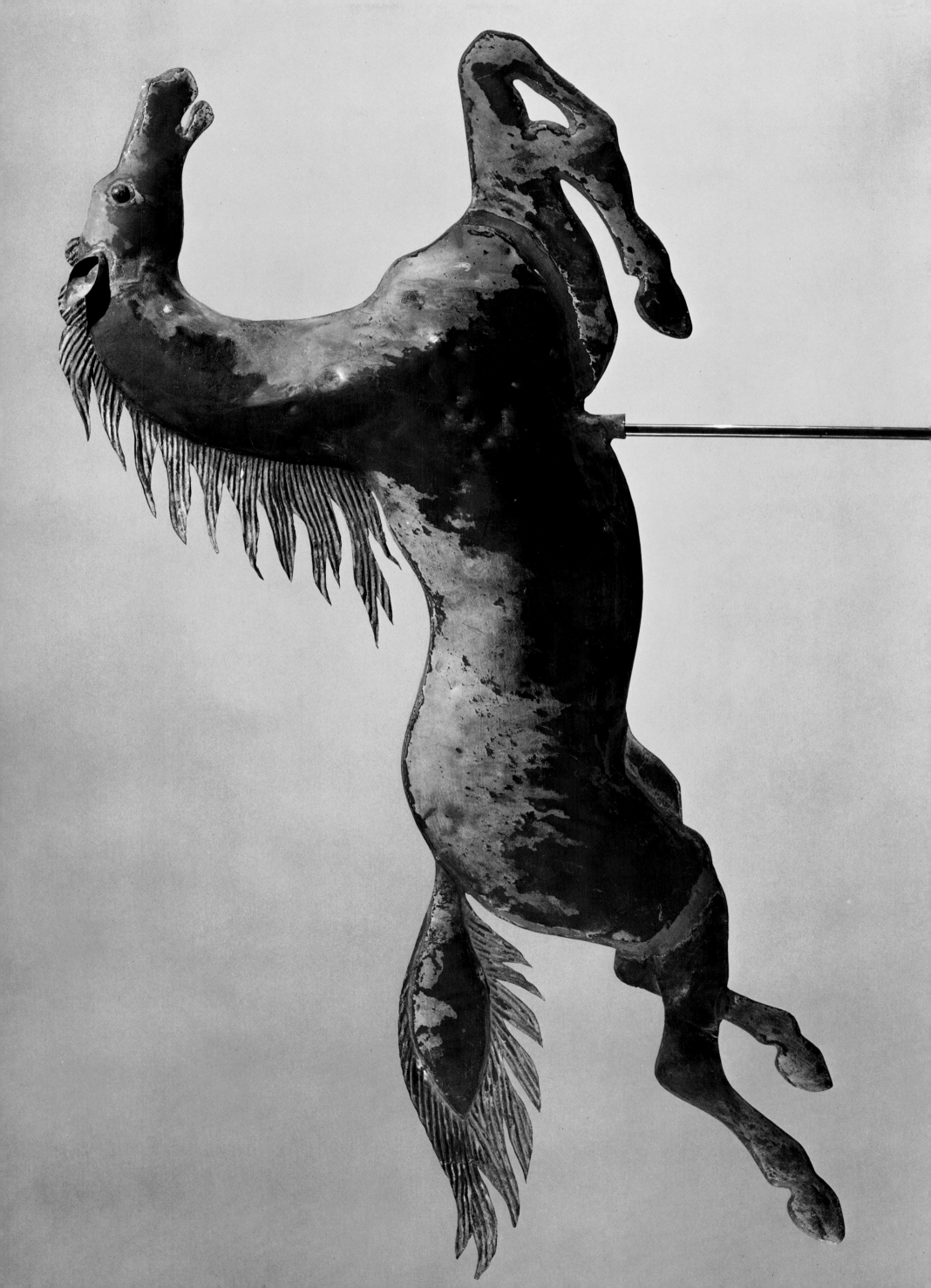

# BOTTLE-CAP BASKET

*Artist unknown. Southern United States. Twentieth century.
Metal bottle caps, h. 12 ¹/₂ ".*

Bottle-cap art is strictly a twentieth-century phenomenon.
Baskets, bowls, and other utilitarian objects have been
fashioned by countless artisans across the country who fol-
low the early American tradition of making something useful
and attractive out of discarded bits and scraps. Few objects of
this type have the coherent sense of design evident in this
piece. (Gift of Charles N. Gignilliat, Jr.)

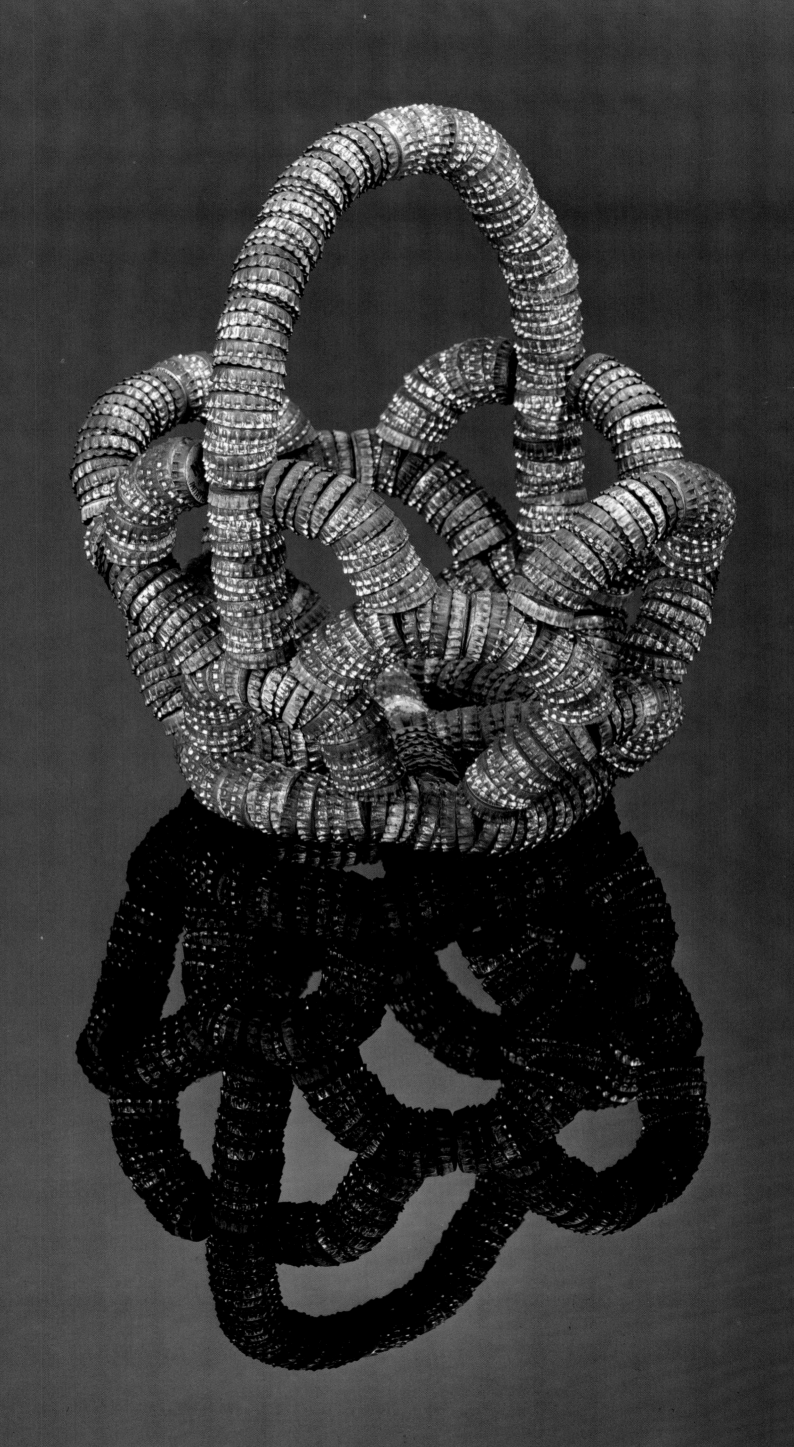

# CIGAR-STORE INDIAN MAIDEN

*Possibly made by Samuel Robb's Studio, New York City.*
*1875–1900. Wood, carved and painted, h. 56".*

Three-dimensional carved representations of the native American Indian were especially appropriate for use as display figures outside nineteenth-century tobacconists' smoke shops, for it was the Red Man who introduced smoking tobacco to early adventurers exploring the New World. Many cigar-store Indians are unique—the result of skillful carving by a single artisan. The majority, however, were created in carving shops where several carvers might work on a single figure, each craftsman executing a portion of the carving that best suited his particular talents. Today, museums and private collectors are most interested in those examples which have been preserved in their original condition, with their painted decoration intact. (Promised gift of Mrs. William P. Schweitzer)

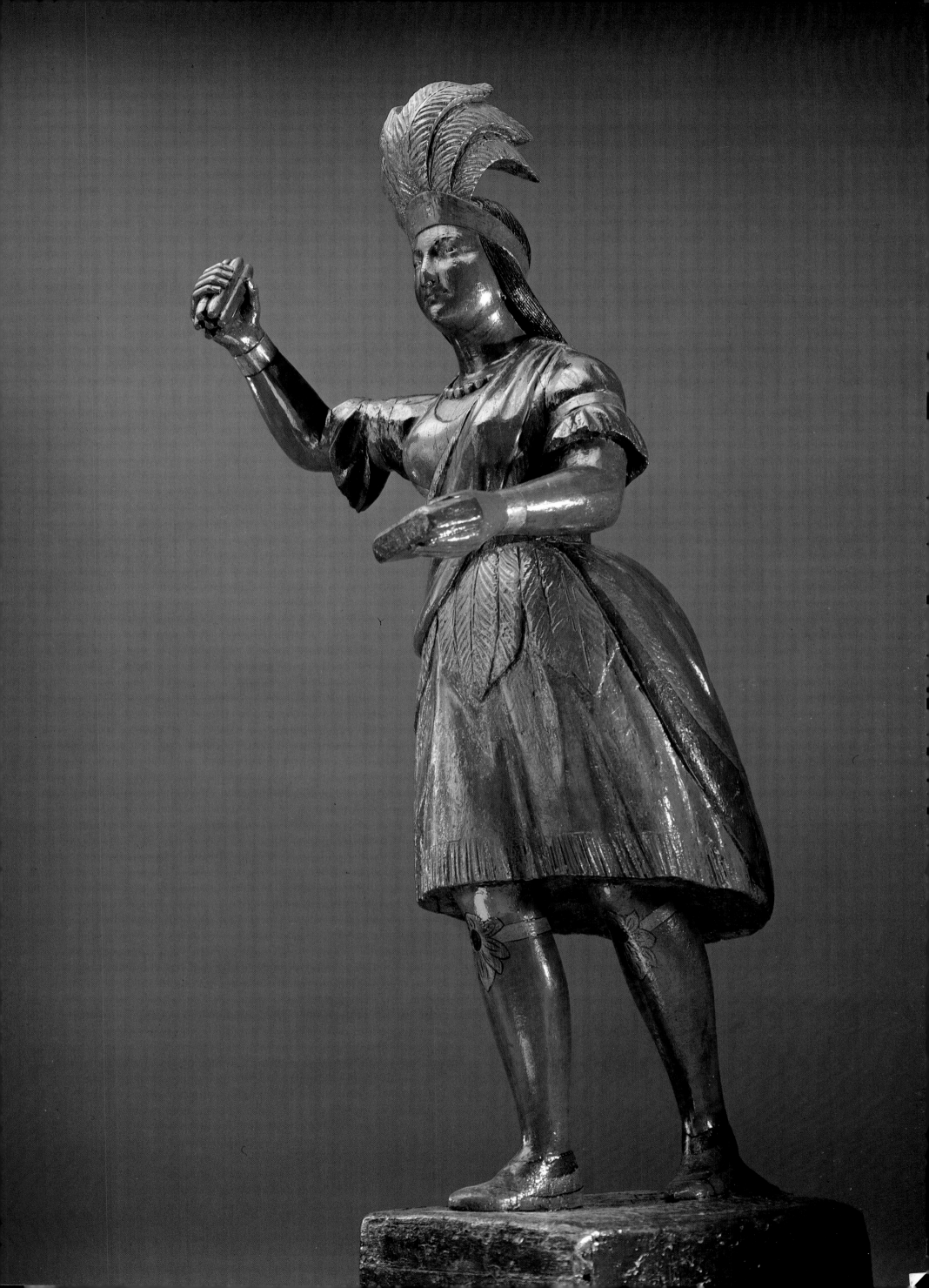

# TURTLE FOOTSTOOL

*Artist unknown. Nineteenth century. Wood, painted, l. 21".*

American folk art is often whimsical. This spotted turtle appears to be smiling, as amused as we are that a commonplace convenience takes such a fanciful form. (Gift of Herbert W. Hemphill, Jr., in the name of Neal Adair Prince)

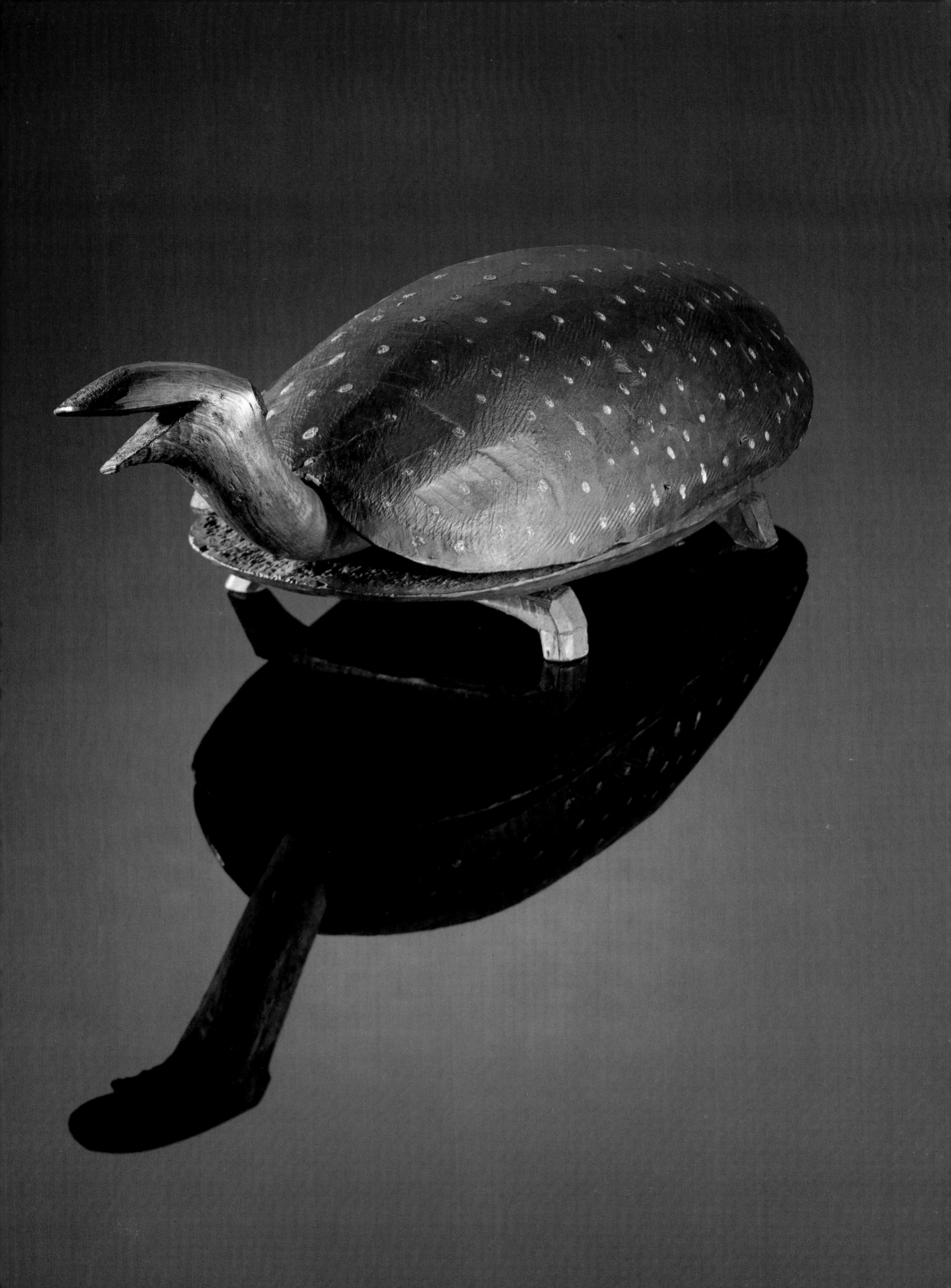

## PORTRAIT OF FRANK PETERS, THE TAILOR

*Joseph P. Aulisio. Stroudsburg, Pa. 1965.*
*Oil on canvas, 28 x 20".*

Aulisio's portrait of the tailor is one of the finest examples of twentieth-century folk art, very much in the tradition of the earliest American folk painting in which naive artists concentrated chiefly on "taking likenesses." This perceptive likeness of Frank Peters has a strength and vitality that transcend time. (Gift of Arnold Fuchs)

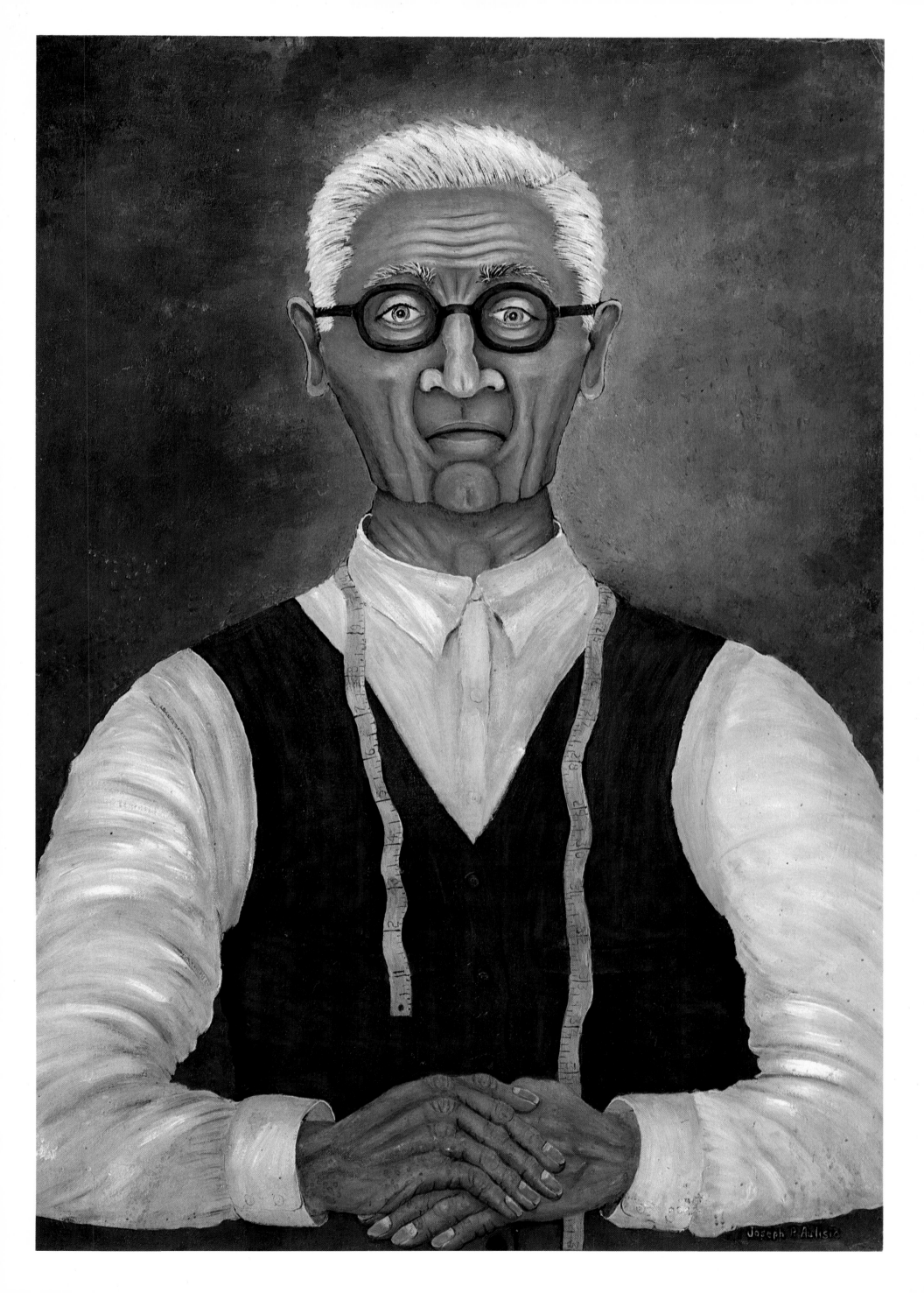

Joseph P. Aulisio

# OVAL BOXES

*Made by a member of a Shaker community. New England.*
*Nineteenth century. Wood, maple, and pine with brass*
*tacks, l. of largest box, 13 $^1/_4$".*

The Shakers, officially known as the United Society of Be-
lievers in Christ's Second Appearing, were a celibate reli-
gious sect founded in the mid-eighteenth century. They
crafted these beautiful and distinctive boxes both for use
within the community and for sale to the outside world. Great
skill was required to fashion the lapped ''fingers'' on the
boxes, some of which are lined with cloth, all of which are
now highly prized by collectors. (Promised anonymous gift)

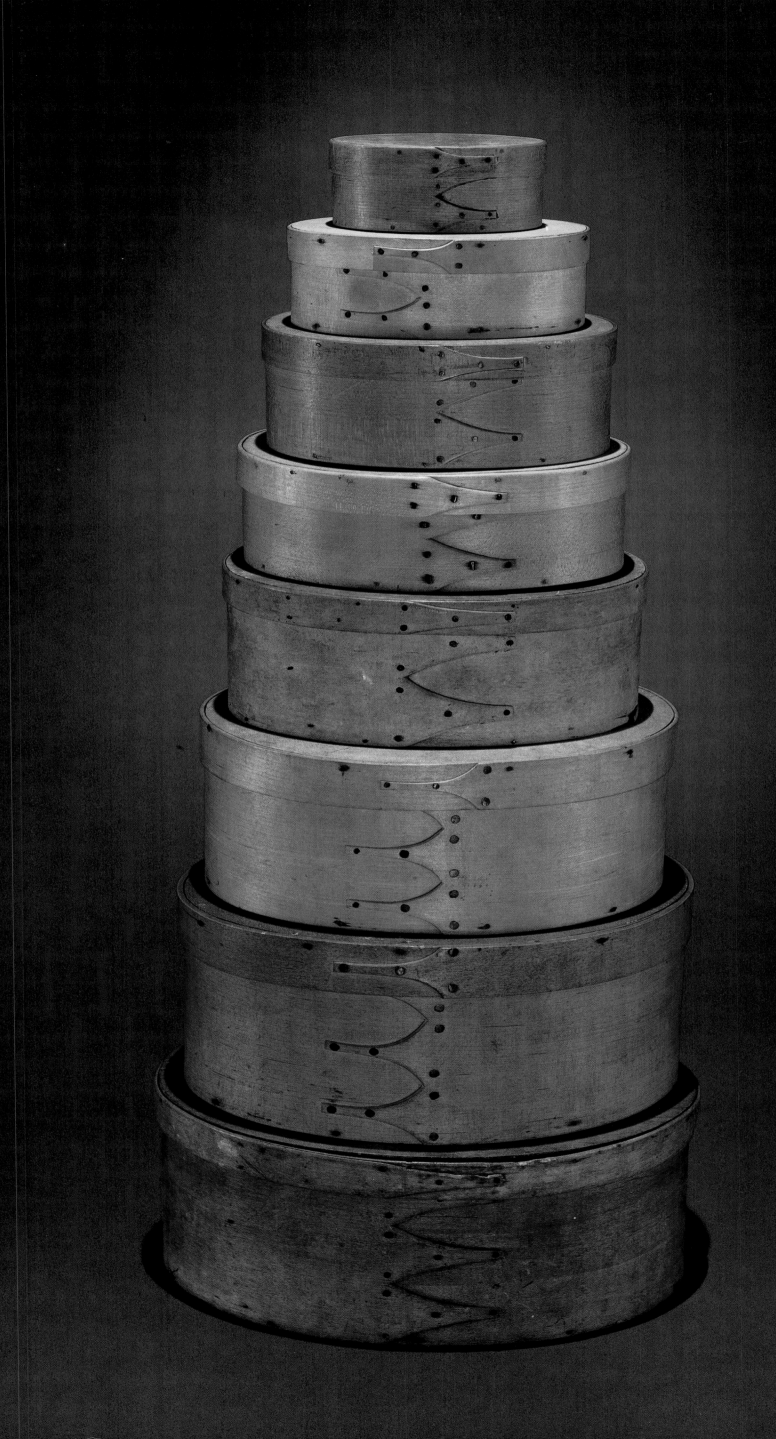

# RAG DOLL WITH DOLL

*Artist unknown. Southern United States. Nineteenth century. Fabric, h. 27 ½".*

While many nineteenth-century American stores specialized in imported manufactured toys, most playthings were created at home. This curly-headed doll, carrying a doll of her own with an acorn cap, wears her original clothes and was probably fashioned by an ingenious woman for her young daughter. (Gift of Mrs. Jacob M. Kaplan)

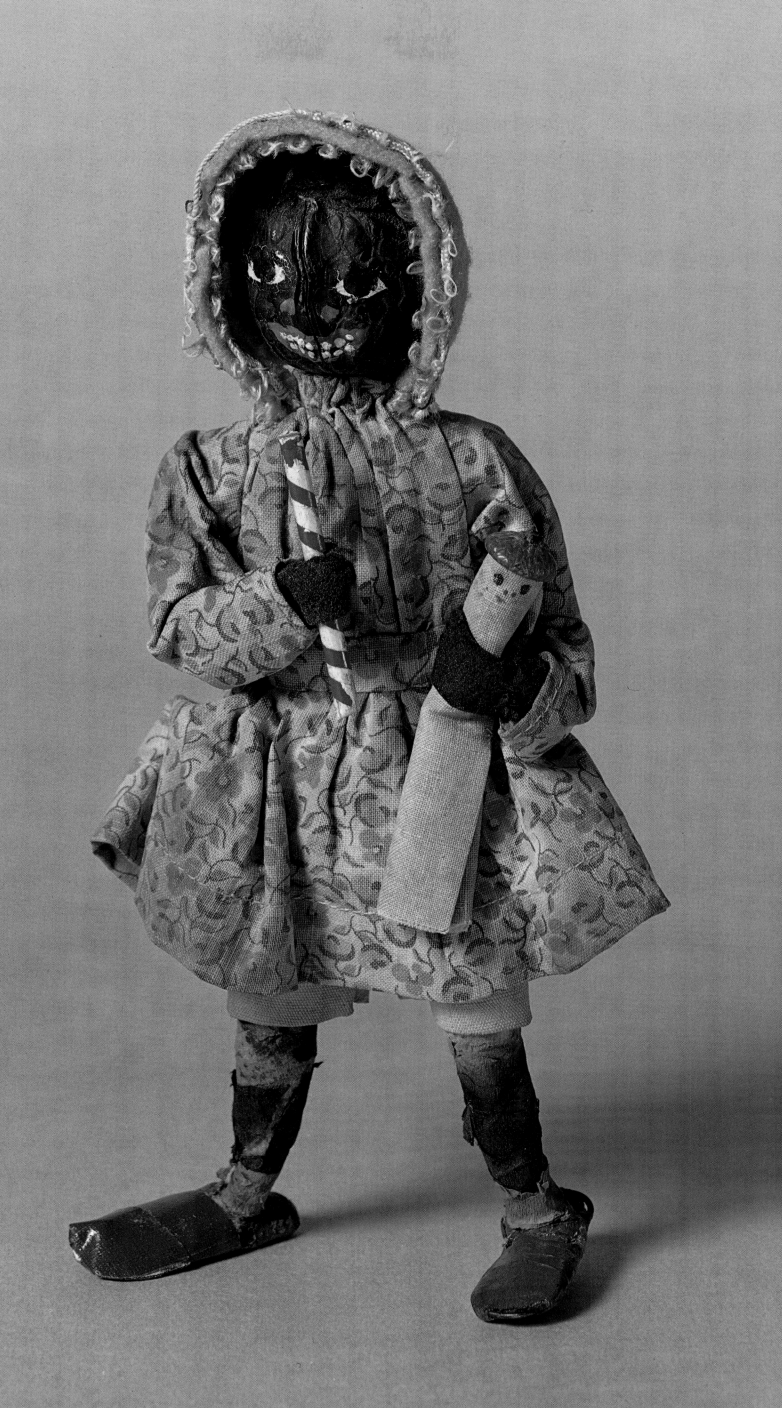

# CAT

*Artist unknown. Pennsylvania. Second half of the nineteenth century. Chalk, polychromed, h. 15 ¹/₂".*

Chalkware served as an inexpensive alternative to the imported Staffordshire pottery that was used to decorate American Victorian homes, and ornaments like this sleek cat, made by a master craftsman, were in great demand. Figures could be made easily and cheaply of a thin plaster mixture of water and gypsum poured into a mold. After it hardened, it was called "chalkware" because it left a white, chalklike mark when rubbed on a surface. The decorations on the finished piece were painted by hand. In Mark Twain's popular novel *Adventures of Huckleberry Finn* Huck observed: "Well, there was a big outlandish parrot on each side of the clock made out of something like chalk and painted up gaudy." (Gift of Effie Thixton Arthur)

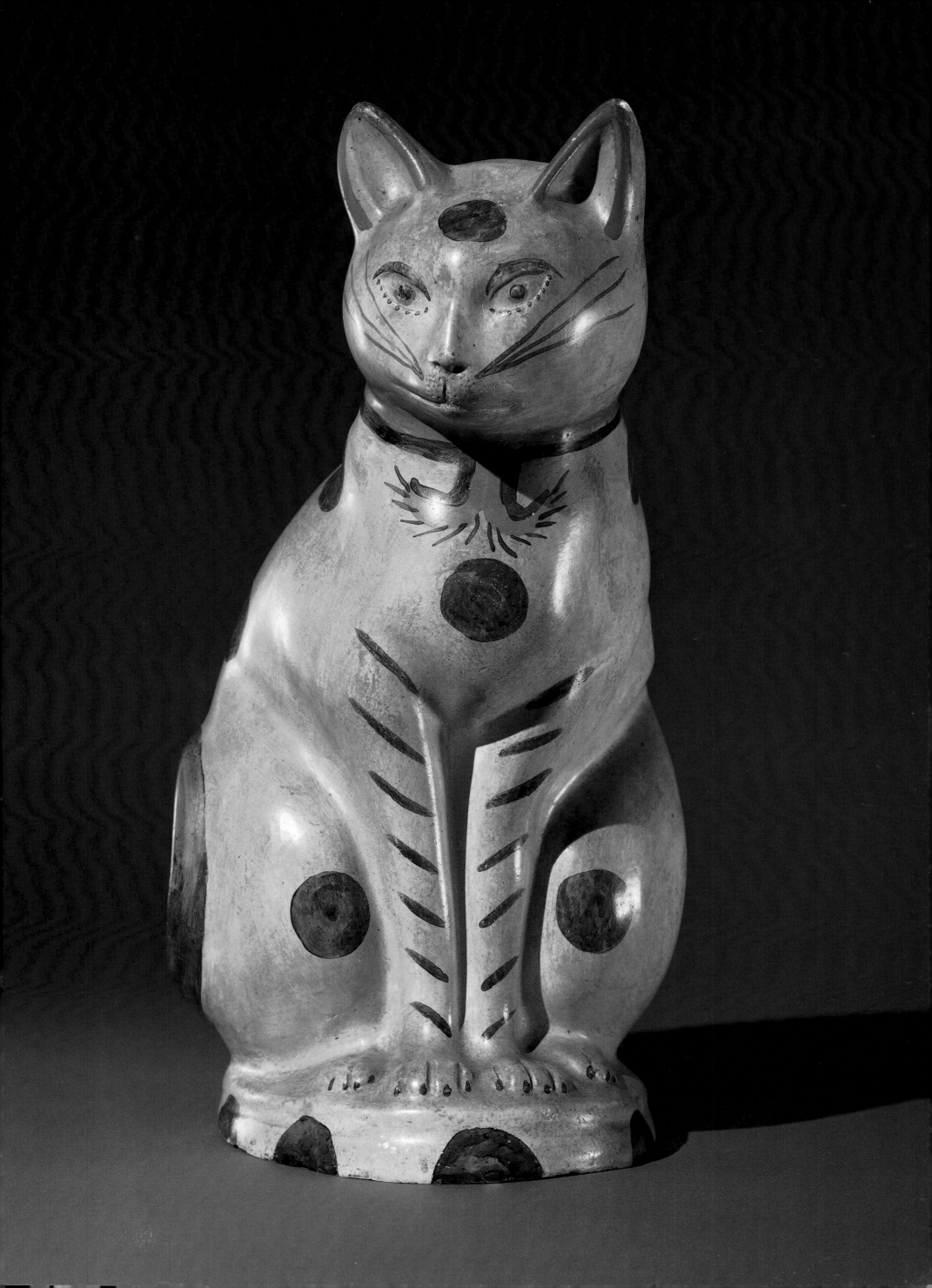

# FLAG GATE

*Artist unknown. From the Darling Farm, Jefferson County, N.Y. c. 1876. Wood and metal, painted, w. 56".*

During the last quarter of the nineteenth century Americans were preoccupied with the Centennial Exhibition, held at Philadelphia in 1876. Patriotic enthusiasm caused many folk artists to turn to themes that would express their Americanism, and a proud farmer glorified his homestead with a gate patterned after Old Glory. (Gift of Herbert W. Hemphill, Jr.)

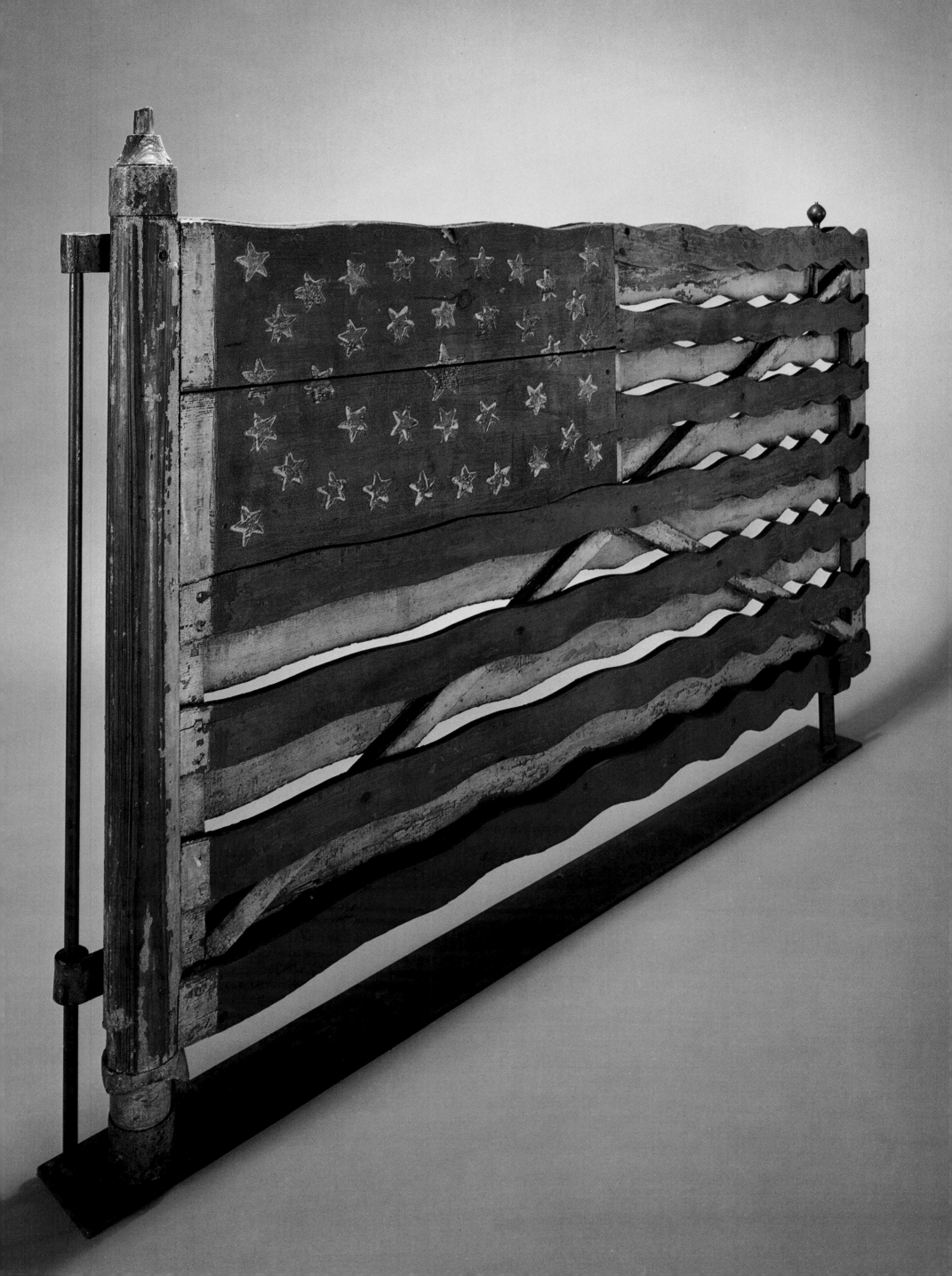

# ROOSTER

*Wilhelm Schimmel (1817–90). Carlisle, Pa. Second half of the nineteenth century. Wood, carved and painted, h. 8 ¹/₂".*

Whittled by a Pennsylvania German itinerant wood-carver known as "Old Schimmel," this rooster is one of approximately five hundred pieces he made in the final twenty five years of his life. Though he was the most talented of the vagrant carvers who wandered about the Cumberland Valley trading wooden likenesses of birds and animals for a meal, a bed, or a tot of rum, Schimmel died in the poorhouse and was buried in potter's field. Today his carvings are collectors' items. This piece, in spite of its diminutive size, has dramatic sculptural qualities that are monumental. (Gift of Ralph Esmerian)

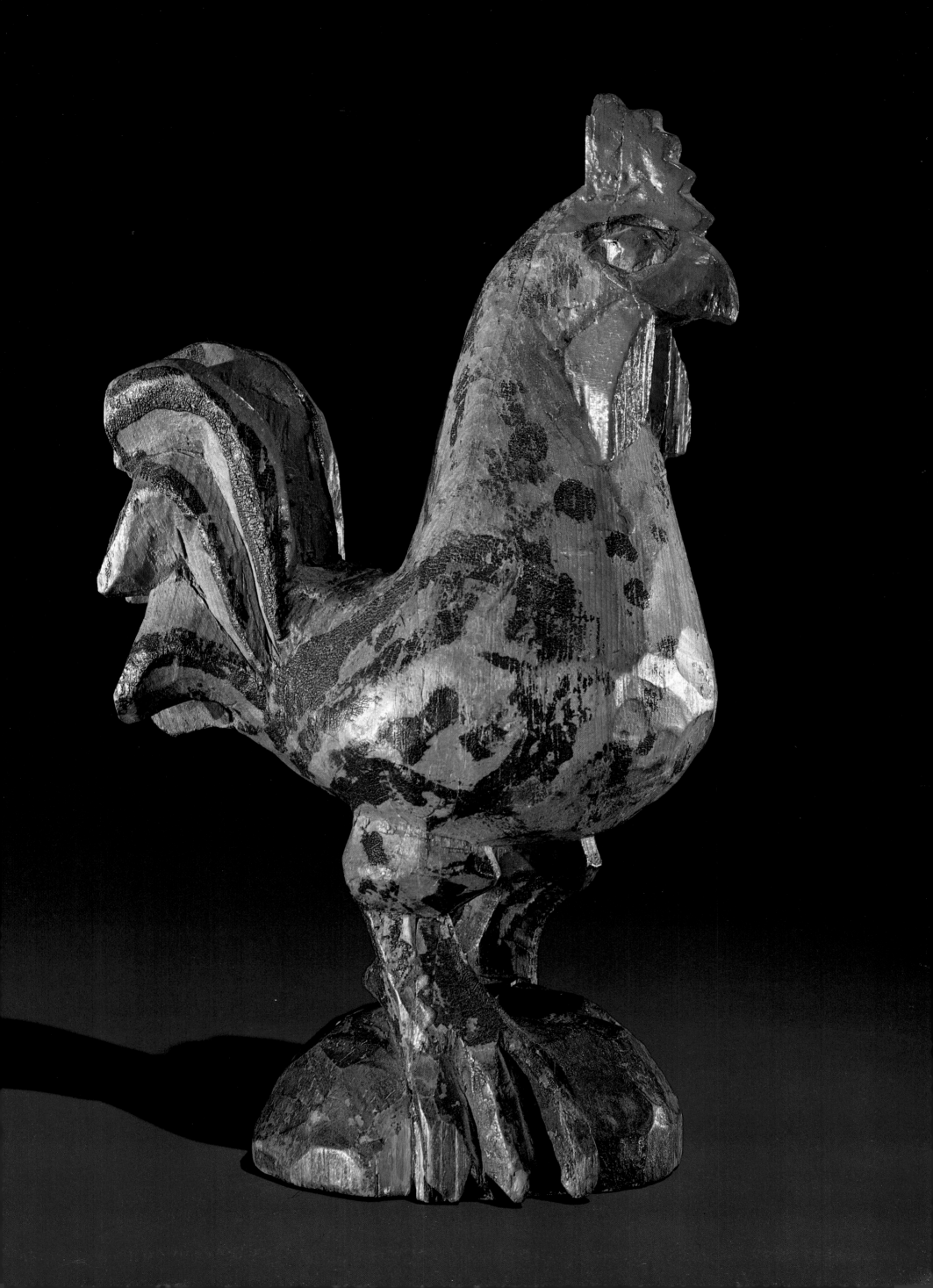

# FATHER TIME

*Artist unknown. c. 1910. Wood, hair, and metal, painted,
h. 48".*

This striking tour de force of American folk sculpture was
once articulated so that the right arm moved and the sickle hit
the suspended bell. The original purpose of this powerful
figure is unknown. (Gift of Mrs. John H. Heminway)

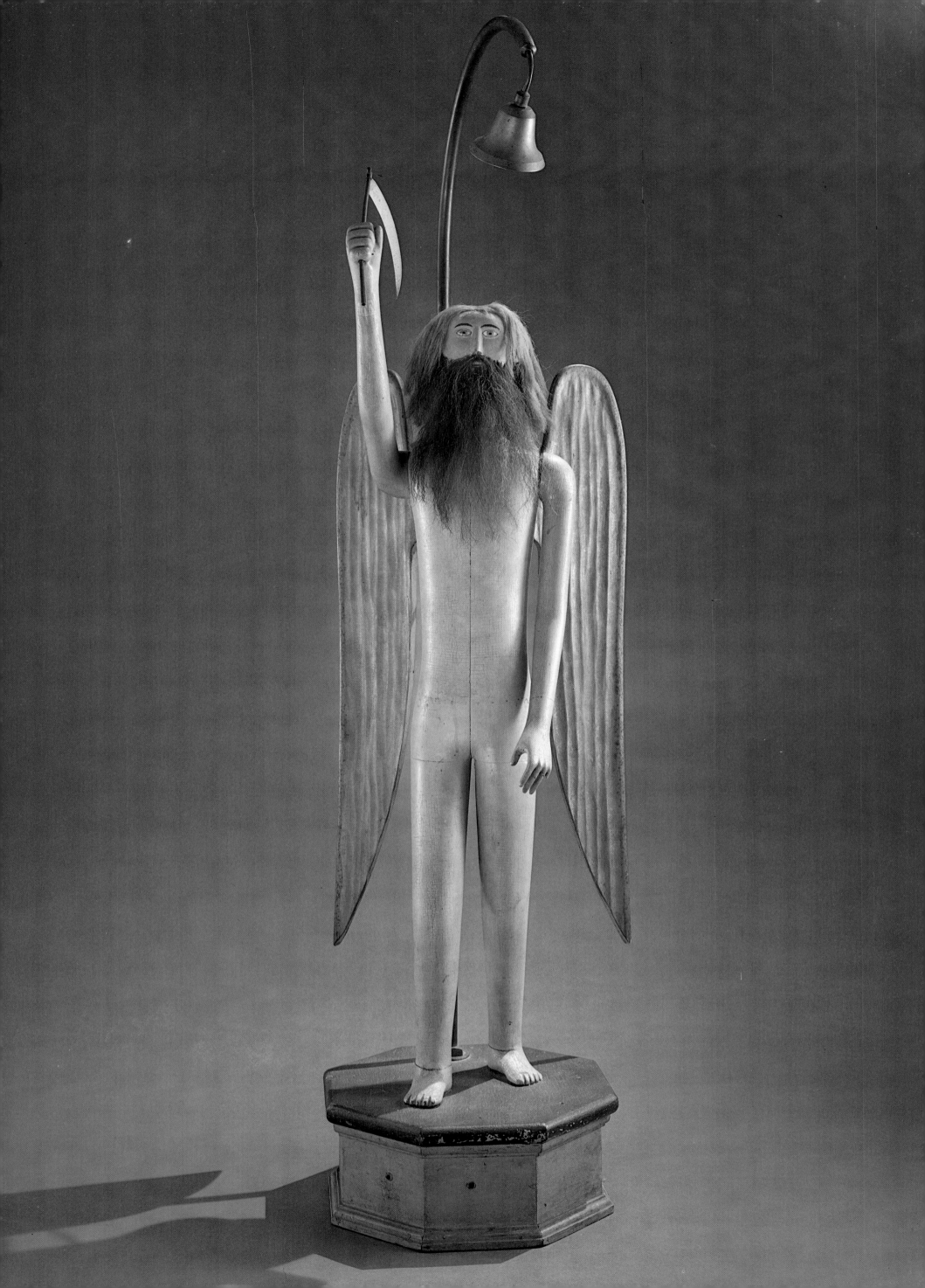